THE
SONG
OF THE
LOOM

NEW
TRADITIONS
IN NAVAJO
WEAVING

THE
SONG
OF THE
LOOM

NEW
TRADITIONS
IN NAVAJO
WEAVING

FREDERICK J. DOCKSTADER

HUDSON HILLS PRESS, NEW YORK
IN ASSOCIATION WITH THE MONTCLAIR ART MUSEUM

First Edition

© 1987 by the Montclair Art Museum

Published in the United States by Hudson Hills Press, Inc., Suite 1308, 230 Fifth Avenue, New York, NY 10001-7704.

Distributed in the United States, its territories and possessions, Mexico, and Central and South America by Rizzoli International Publications, Inc.

Distributed in Canada by Irwin Publishing Inc.

Distributed in the United Kingdom, Eire, Europe, Israel, and the Middle East by Phaidon Press Limited.
Distributed in Japan by Yohan (Western Publications Distribution Agency).

Editor and Publisher: Paul Anbinder

Copy editor: Stephen Robert Frankel

Proofreader: Eve Sinaiko

Designer: Betty Binns Graphics/Martin Lubin

Composition: Trufont Typographers

Manufactured in Japan by Toppan Printing Company

Library of Congress Cataloguing-in-Publication Data

Dockstader, Frederick J.
 The song of the loom.

 Catalogue of an exhibition held at the Textile Museum, Washington, D.C. beginning in March 1987, and at other museums.
 Bibliography: p.
 Includes index.
 1. Navajo Indians—Textile industry and fabrics—Exhibitions. 2. Indians of North America—Southwest, New—Textile industry and fabrics—Exhibitions.
I. Textile Museum (Washington, D.C.) II. Title.
E99.N3D56 1987 746.7′2 86-27610
ISBN 0-933920-87-3 (alk. paper)

THIS EXHIBITION
IS DEDICATED
TO THE MEMORY OF
ALVIN W. PEARSON

CONTENTS

FOREWORD

The Montclair Art Museum is pleased to be associated with the Textile Museum, Washington, D.C., in the presentation of *Song of the Loom: New Traditions in Navajo Weaving*. This is the fourth in a series of exhibitions dealing with the textile arts which have appeared in both museums: *The McMullan Collection*, 1968, was organized by the Smithsonian Institution; *Prayer Rugs*, 1975, and *Turkmen, Tribal Carpets and Traditions*, 1980, were organized by the Textile Museum; and now, *Song of the Loom: New Traditions in Navajo Weaving* has been organized by the Montclair Art Museum.

All four collaborations were facilitated by Alvin W. Pearson (1902–1986). Mr. Pearson served as president of the Board of Trustees, as chairman of the Art Committee of the Montclair Art Museum, and as honorary trustee of the Textile Museum. A past president of the Haji Baba Club and an avid collector specializing in Turkman carpets, he had a range and depth of connoisseurship that were formidable. It was his fine and discerning eye that recognized and brought to my attention the quality of the private collection from which the textiles in this exhibition have been selected.

Mr. Pearson died in May of 1986. It is with pride and affection that we dedicate *Song of the Loom: New Traditions in Navajo Weaving* to his memory.

Dr. Frederick J. Dockstader has served as both curator of the exhibition and author of this catalogue. He has given an extra dimension to our efforts, not only through his profound scholarship and encyclopedic knowledge but also through his understanding and warm sympathy for the Native American, particularly for the weavers whose work we feature.

I extend warmest thanks to Patricia L. Fiske, former director of the Textile Museum, for her unfailing sympathy and wise collaboration and support, and to the Boards of Trustees of the Montclair Art Museum and the Textile Museum for their belief in the project. The following staff members of both institutions must be recognized for the hard work and professionalism they dedicated to the exhibition, to the programs that accompany it, and to the catalogue:

At the Textile Museum, Washington, D.C.: Ann Rowe, curator, Western Hemisphere Textiles, who read Dr. Dockstader's text in draft and made valuable comments and suggestions; Jane Merritt, conservator, who supervised the preparation of the textiles for the exhibition; Julie Haifley, registrar, who worked closely with the Montclair Art Museum staff in making arrangements for packing and shipping; and

Richard Timpson, who oversaw installation of the exhibition at the Textile Museum.

At the Montclair Art Museum: Hope Morrill, registrar, who supervised endless details of insurance, packing, transportation, and registration; Alejandro Anreus, research associate, who helped Ms. Morrill in every way; Ronald Lomas, installation specialist, responsible for the installation of the exhibition at the Montclair Art Museum; Walter Poleshuck, deputy director for public affairs, and his staff, Eileen Tokar, Wendy McNeil, and Mary Robertson, who worked unceasingly to fund the project; Louise Horgan, coordinator for public relations and publications; and her assistant, Laura Luchetti, who designed promotional and publicity materials; Janet Cooke, curator of education, who designed the programs accompanying the exhibition at the Montclair Art Museum; and Haleh Samii, executive secretary to the director, who bore it all with admirable patience.

In addition, we are grateful to the private collector who has consented to lend us his treasures, acquired with much determination and discrimination, and for allowing their exhibition for so long a period of time.

Our best and warmest thanks, however, must go to the weavers who have not only preserved their ancient art but renewed it with love, perseverance, and skill, and who have allowed us through this exhibition and catalogue to share it with a wide public:

Marie W. Begay	Dorothy Mike
Roselyn Begay	Nellie Nelson
Vera Begay	Despah Nez
Mrs. Big Joe	Laura Nez
Suzy Black	Maggie Price
Helen Burbank	Daisy Redhorse
Mary Chee	Betty Roan
Ruth Corley	Mary Smith
Rose Dan	Anna Mae Tanner
Virginia Deal	Daisy Taugelchee
Dorothy Dee	Priscilla Taugelchee
Dorothy Francisco	Alberta Thomas
Bessie George	Stella Todacheeny
Cecelia Joe	Katie Wauneka
Grace Joe	Audrey Wilson
Julia Jumbo	Betty Joe Yazzie
Mrs. Mike Keyonney	Margaret Yazzie
Marie Lepahie	Philomena Yazzie
Angie Maloney	Rita Yazzie
Mrs. Sam Manuelito	Sarah Yazzie

ROBERT J. KOENIG, DIRECTOR
The Montclair Art Museum

PREFACE

Although each of us may feel its emotional appeal to a greater or lesser degree, almost everyone shares a common interest in and fascination for the innate human ability to produce art of whatever design, style, or form. While the latter may vary from one culture to another, and the responses to that creative drive may range widely—in proportion to the social drives, cultural strictures, and the environmental resources available—the one common denominator is a concern for the esthetic, however that may find expression. Indeed, of all of the qualities that separate humans from other forms of life, the highest is the ability and desire to create art; and of all the modes of expression of a given culture, visual art is the most distinguishing feature by which that culture may be identified. Music, language, and even much of the religious, economic, and social customs that we tend to take for granted as permanent are only transient at best; but by and large it is the art of a people that endures to tell us most of what we may know about those who created it.

However, this does not happen without effort; over the many centuries of Man's evolution, there have apparently always been those individuals who, for whatever reason, have taken pride in doing or creating something as good as the best—or just a little bit better. Indeed, this element can be argued as the true essence of art; and it is to those artists who have taken one step further,

passing their skills on to their children, urging them to follow their lead, that an acknowledgment is due. Most of these ancient practitioners have passed on without leaving their names or identities; but, fortunately, as the role of the individual has become more important, there has accumulated a slowly increasing permanent record of the artists who have created the most important objects of human cultural development.

Therefore, in this catalogue of the *Song of the Loom* exhibition, an initial expression of appreciation seems fitting to those artists who have made it possible. For the weavers whose work is included in the exhibition, I have identified them wherever such identification is possible; in addition, I have provided a list of their names and, where the information was available, biographical notes, in a special section at the end of this catalogue. It is gratifying to be able to make the point that such a record of artists can now be compiled for an event of this nature. Half a century ago, although the object itself was beginning to be more widely appreciated, little thought was given to recording the identity of the maker, and such a catalogue would not have been possible.

The record of the nonweavers who organized *Song of the Loom* for public presentation is more available, and for their participation in the many aspects of the

project, a special word is due. Certainly first in precedence is the individual who has been primarily responsible for preserving the examples in this collection and making them available to the Museum. Although we must respect his wishes for anonymity, we would like to acknowledge here his clearly demonstrated devotion of time and substance, without which no such exhibition could take place—and of equal importance, his generous willingness to allow the exhibition to be transported to several distant locations where it could be enjoyed more widely, for which we are grateful.

Closer to home are several people who merit a special word of appreciation: Brenda L. Bingham and the late Alvin W. Pearson, past presidents of the Board of Trustees of the Montclair Art Museum, who were instrumental in developing interest and support for the decision to undertake this exhibition; and Robert J. Koenig, director of the Museum, who took the initiative in eliciting interest in having the exhibition travel beyond the boundaries of the Museum itself. Hope Morrill, the Museum registrar, undertook far more than the usual duties associated with her position.

For their special interest and assistance, warmest thanks are extended to Roy Davis, assistant director, and Stephen R. Edidin, curator. For their persistent and expert efforts to secure funding for the exhibition, we extend our deep gratitude to Walter Poleshuck, deputy director for public affairs; and Eileen Tokar, development coordinator.

Appreciation has already been expressed to the Montclair Art Museum administrative staff. At the Textile Museum, we are especially aware of the cooperation of Patricia L. Fiske, past director, whose agreement to participate as a co-sponsoring facility insured the success of a traveling exhibition, and most particularly thank Ann Rowe, who carefully read the manuscript and took time from a busy schedule to provide an eagle-eyed critique which smoothed out many rough spots.

As this project grew, we went in search of more information about the weavers themselves, and in so doing, we aroused the interest of Edith and Troy Kennedy, owners of the Red Rock Trading Post, Arizona; and Anne and Arch H. Gould, of Grand Junction, Colorado, whose fine collection is a tribute to their longtime devotion to Navajo weaving. These people were well acquainted with most of the weavers still living and graciously took on this task. The results can be found in the biographical sketches appended to this catalogue, together with photographs of some of the women who created these textiles. Additional help came in the generous contribution of superb portraits of some of the weavers by Paul Markow, a photographer from Phoenix, Arizona.

Cordial acknowledgment is also extended to Ellen Page Wilson, whose photographic skills are manifest in the illustrations that effectively represent the quality of the textiles; to Paul Anbinder, of Hudson Hills Press, for his skill and patience in guiding the manuscript through the vagaries of publication; and to Stephen R. Frankel, whose editorial skills are manifest on every page. The willing help of Mary B. Davis, librarian, and the staff of the Huntington Free Library, Bronx, New York, for providing needed research assistance is not overlooked. I am also happy to express my gratitude to several friends for their kind assistance: to Al Packard and Tom Woodard, of Sante Fe, both veteran traders whose experience with Navajo weaving was of inestimable help; to Rain Parrish, curator of the Wheelwright Museum, Santa Fe, an ever willing source of information; to Ann Hedlund, curator of the Millicent Rogers Museum, Taos, whose help even she may not be conscious of. And lastly, I am deeply grateful to Kate Peck Kent, School of American Research, Santa Fe, for permission to adapt the loom diagram on page 29 (Kent, 1985), and to the University of Oklahoma Press, Norman, for permission to reproduce the map on page 12 (Goodman, 1982).

THE
SONG
OF THE
LOOM

NEW
TRADITIONS
IN NAVAJO
WEAVING

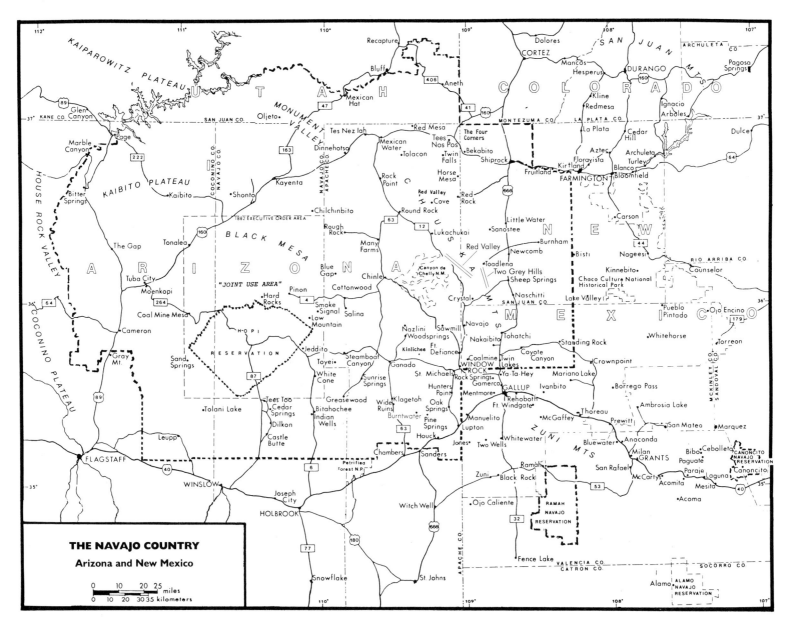

THE NAVAJO COUNTRY

Arizona and New Mexico

0 10 20 25 miles
0 10 20 30 35 kilometers

From *The Navajo Atlas: Environments, Resources, People, and History of the Dine Bikeyah*, by James M. Goodman.
Copyright © 1982 by the University of Oklahoma Press.

INTRODUCTION

One of the attitudes frequently encountered concerning many forms of art—and most particularly in the field of American Indian art—is that the work today is not as fine as it used to be. At first glance this may seem true, since much of the "Indian art" offered in most curio or souvenir shops is of average quality and may or may not reflect the best efforts of the maker.

But any examination of the products of the best artists, displayed at a museum exhibition, a major competition, or in one of the better-quality galleries, will quickly demonstrate the fallacy of the statement. When they put forth their very best efforts, those individuals in whose body flows the blood of the old-time artists are today capable of producing classic examples of weaving, silver, and ceramics every bit the equal of their ancestors and can often surpass them, both technically and esthetically. *Song of the Loom* is dedicated to this premise; and although not every example in the exhibition is of that superlative quality, all are of an excellence that show the skills of the fifty-five weavers (forty known and fifteen anonymous) whose work is included. Moreover, a majority of the eighty-three textiles that have been selected comprise a well-balanced demonstration of the very finest weaving skills of any period in Navajo history.

This exhibition grew out of a recent opportunity to view a private collection of Navajo weaving that had been formed over the past quarter century. The owner had been introduced to Navajo weaving, became enthusiastic over the work of several contemporary artists, and set about to build a collection that would represent the best work available. He also became deeply interested in a group of women who were specializing in weaving textiles based on the designs of the sand paintings that the Navajo people created for their religious ceremonies. Commonly known as Chant Weaves, or Chant Rugs (both terms are unfortunate for what are technically not weaves, but styles, and are normally used as wall hangings rather than as floor rugs), these had recently become more available as the long-honored taboo restricting the representation of religious designs began to ease. In time, he gathered a great many of them, forming what is perhaps the largest single collection in existence of this particular design style.

Fortunately, these were not only rare examples of an unusual art form but were also in themselves examples of superb esthetic and technical weaving skill. The quality and subject matter provided an

opportunity to create an exhibition that would achieve several goals: demonstrate the continuum of Navajo weaving and thereby counter the belief that the art had died with the passing of the nineteenth century; introduce the remarkable variety in color and design inherent in Navajo religious art as interpreted by skilled weavers; and present a selection of some of the finest weaving being created today from several areas in the Navajo country.

While there are a few early examples included for comparison, this is not intended as a historical survey. There have been many excellent reviews of Southwestern weaving concerned with the past; this exhibition is dedicated to the contemporary Navajo artist and her fulfillment of the promise of that past. In this effort, we have chosen to focus upon the Chant designs for several reasons. They are less familiar to most people; they display a greater range of textile design and technique; they represent a remarkable sociological triumph, for which we salute the weavers; and their powerful designs and colors give them an eye-stopping quality that justifies their place in Navajo esthetics.

A glance at the Bibliography will reveal how little has been written about this particular style; hence our hope that this exhibition will not only provide the viewer with a greater understanding of the art but also serve the weavers in giving their work a larger audience. To achieve this end, we have included among the thirty-one ceremonial designs a full set of the fourteen designs from the Great Star Chant; five from the Red Ant Way; four from the Coyote Way; and eight miscellaneous ceremonial subjects, so as to give a sense of their rich complexity and diversity.

Anyone who has been fortunate enough to observe a Navajo weaver at work, admiring the dexterity of hand, sureness of eye, and sense of design balance, has enjoyed a profound sense of appreciation for artistic skill. And the singing that often accompanies the weaving as she slowly builds the textile on her loom

Singing to the Spider Woman for inspiration;

Singing to pass the tedious hours;

Singing for the joy of creation; and

Singing of the beauty above and around her

will leave the viewer with an unforgettable impression of melody combined with visual beauty. Hence the title of this exhibition.

SONG OF THE PAST

THE TRADITIONS

We do not know precisely when the Navajo people came into the Southwest; most scholars estimate that it was probably not much over five hundred years ago, and perhaps slightly less. They were part of the great Athapascan-speaking group related to the Tlingit of Alaska, who slowly moved southward until they settled in their present home. At that time they were primarily a nomadic hunting-farming-gathering folk, accustomed to raiding the various Pueblo people whom they found already long established in cliff dwellings. Early in their settlement, several of the major Navajo bands split off from the parent group and wandered farther south, eventually becoming the Apache, who still occupy areas of New Mexico and southern Arizona.

Navajo accounts of their origin, or Emergence from the other world into the one in which we all live, have also become interwoven with those of the Pueblo peoples; in general, they include many episodes that agree markedly with the archeologist. As they slowly developed into the Navajo people we know today, they adopted many other cultural characteristics of their Pueblo neighbors; most of these innovations were introduced via intertribal trading, natural propinquity, and the presence of Pueblo

wives or slaves captured by raiding parties who, willingly or not, became part of the Navajo tribe.

We do not know whether or to what degree the Navajo already knew the weaver's craft; some authorities argue that they did not. They did enjoy a very well-developed mastery of basketry; and the presence of a small number of weaving tools found in context with ancient Navajo archeological sites supports the belief that they may indeed have had some embryonic textile skills. However, the scarcity of such evidence leads one to feel that these could not have been very highly developed.

But a far greater impact was probably effected after the Pueblo Revolt of 1680–92; when the Spaniards returned, many Pueblo families fled to the more distant Navajo areas for protection, remaining there for many years. It is during this period that most scholars believe the Navajo first learned weaving, as they saw the well-made textile clothing of their guests (compared to their own animal-hide or simply woven garments) and began to adapt Pueblo costume to their own needs. Whereas little note had been made of Navajo costume

prior to this period, by 1706 the Navajo were commonly wearing garments that were finely woven and trading their textile products to the Spaniards, indicating a rapid advancement in their weaving skills and in the quantity of product (Wheat, 1977: 424).

Several influential changes took place at this time; the most important by far was the introduction of wool, replacing cotton. Although the Spanish *churro* sheep was already a part of the Southwestern landscape, the new weaving techniques (if indeed they were new) created an expanding need for weaving materials. For at least eight hundred years, cotton had been the principal Pueblo fiber, and it continued to be. But the Navajo, recognizing the superior qualities of wool for weaving—its greater strength, long fibers, ease of spinning, and receptivity to dye—turned to the sheep as a major resource for weaving, as well as an important source of food. In almost one stroke the tribe became herdsmen, with a textile economy, living on a mutton food base supplemented by agriculture and hunting.

And one other transformation became important. Whereas Pueblo men had been the weavers, with only a few women engaged in the art (most especially at Zuni, where it was a woman's occupation), the position of Navajo men as mobile hunters, warriors, and raiders caused the Navajo women to adopt the craft as their own. This change was undoubtedly facilitated by the fact that weaving is often a part-time activity, which can be successfully pursued by a person busy with other tasks at the same time—tending children, cooking, gardening, and related domestic duties.

While the Navajo are famed as a highly adaptive society, they are equally inventive; and thus they developed new techniques, designs, and textile forms that in a relatively brief period of time far surpassed those of their Pueblo teachers. The latter have tended to continue to the present in a relatively conservative fashion, weaving the same materials and garments with almost identical patterns. Although there has been some attrition in the quantity of handmade Pueblo textiles, due to the introduction of manufactured garments, little has changed in their quality and style.

As the Navajo increasingly explored the art of weaving, trying new techniques, dyestuffs, and designs, their natural skills responded. Their first weaves were direct copies of the traditional banded wearing blankets favored by the Pueblo people. The introduction by the Spaniards of new motifs gave rise to the beginning of an increasingly expansive art form, an influence that intensified after the Mexican Revolution, when the *poncho* and *serape*, with decorations characterized by small spots, diamonds, and triangle-and-zigzag motifs, became more prevalent. Another major source was Navajo contact with the Mexican refugees who settled along the Upper Río Grande and developed what has become known as the Chimayó style, in which those same serrated diamond-and-line designs are dominant.

By the beginning of the nineteenth century the Navajo women had fully established a mastery of the art, in which their tightly woven textiles had become essential to the lives and comfort of the several peoples of the Southwest—particularly in the form of wearing blankets, saddle pads, and bed covers. Their fame extended far beyond their homeland, as Plains Indian traders sought out the colorful, warm tex-

tiles. The sheep-based economy had created a prosperity unknown before or since. Raw wool had become valuable as an export; mutton was a staple food for both consumption and sale; and the woven products of the loom brought a tremendous income to the weavers and traders.

This was brought to a sudden halt by the intervention of the United States Government into the region—most dramatically, the incarceration by the U.S. Army of most of the Navajo tribe in 1863, when some nine thousand men, women, and children were forced to take the infamous Long Walk to Bosque Redondo, in eastern New Mexico, where they remained until 1868. Almost one-third of the people died of illness, starvation, or injury on the way or during the five-year confinement.

But with their return to their homeland, an astonishing revival took place. Although they had lost their sheep, most of their land and possessions, and much of their cultural freedom, they were soon able to reestablish themselves to an almost unparalleled degree. Forced to abandon their old nomadic ways, the men turned to agriculture and took up a new art—silversmithing—while the women returned to their shepherding and an increased attention to weaving, and in so doing evolved a new way of life.

Weaving was greatly affected by two events. During their confinement, the government gave the captives approximately four thousand Río Grande blankets for protection from the cold and, upon their return to their homeland, thirty thousand dollars for the purchase of sheep to provide food and wool. The serrated diamond-and-line blanket motifs were popular and influenced Navajo design for decades; and while the need for food was vital, of equal importance was the need for wool for weaving and for raw sale (Wheat, 1975: 14).

Toward the end of the century, White settlers and traders from the eastern states further strengthened the growth of the textile arts with an increased demand for woven products, the introduction of new design elements, and, most especially, the involvement of traders as entrepreneurs. Of these latter, Juan Lorenzo Hubbell, John Bradford Moore, Clinton N. Cotton, and Thomas Varker Keam were among the most influential. Each was responsible for establishing a level of quality and for initiating a design or style that has become "traditional" Navajo weaving today—even though in many instances the source of the influence was completely non-Indian.

Designs were selected at random from a great range of textile motifs, Occidental and Oriental, plus some wholly invented by the traders according to their own notions of what Indian weaving should look like. These were shown to, or drawn for, the weavers, and since the trader bought only what he liked, the result was predictable. However, the women interpreted these in their own way—as they had with earlier adaptations—giving a certain flair to them which eventually resulted in a compatible form and style. It is this subtly intertwined evolution that is "traditional" Navajo weaving today.

Not only did the traders introduce new designs, colors, and commercial dyes, but they also wrought a dramatic change in the function of Navajo weaving. Whereas textiles earlier were made primarily for body covering, sleeping blankets, and saddle pads, the White settler also required floor coverings. This was certainly not an unknown use, but rugs soon assumed a new importance, and the weaver had to adjust to

producing thicker textiles, woven in sizes more suitable to the homes of the *Bilagana*, as the Navajo called the White man. This meant not only yarn changes but larger looms, which have remained standards to the present time.

Although the Navajo were very conscious of the quality of the wool required by weavers for best results, efforts by the Bureau of Indian Affairs to introduce other breeds of sheep resulted in periods of success or decline during experimental years; and over-grazing and its effect upon the land resulted in a forced, if ecologically necessary, reduction of flocks by the government, instilling in the Navajo a psychological trauma that remains to this day. Fortunately, the efforts of another Federal agency, the Indian Arts and Crafts Board, formed in 1934, did much to overcome the disastrous national policy of eradicating native language, religion, and customs. This was one of the first governmental groups whose mandate was specifically to improve the cultural well-being of the Indian. It established a program devoted to creating a greater regard for the arts of the Native Americans and gave these demoralized people a much-needed sense of self-worth and dignity.

Following World War II, returning veterans who had served with outstanding valor in specialized Indian detachments—notably the Navajo Code Talkers, which happened also to include some artists and individuals especially concerned with art—brought a new sense of self-identity to the Navajo. Many of these young men turned their efforts to the political, social, and economic betterment of their people, some with a particular emphasis on artwork, especially silversmithing and weaving, and a revitalization of the Navajo Arts and Crafts Guild under the aegis of the Navajo Tribal Council. This had initially been organized in 1941 by the Indian Arts and Crafts Board but had lapsed during the war; the interest of several veterans, notably Ned Hatathli and Carl Gorman, revived an active and influential agency for craft standards that thrives to the present time.

And, closely related to the interests of these veterans, it seems undeniable that the major impetus of the past half century toward the preservation and strengthening of Navajo weaving has been the White art world, for better or for worse. Although the production and sale of raw wool, commercial rugs, and silver jewelry were important and remain so, the interest of artists, art scholars, crafts people, and art-gallery entrepreneurs has created a widening body of individuals and institutions appreciative of the qualities of Navajo textiles and actively interested in their promotion and preservation. Some of this effort undeniably represents an intervention for personal profit or for gratification; but much of the day-to-day concern has been sincere and well thought out, serving the needs of the art and the artist in an equally beneficent manner.

Fairs, demonstrations, and exhibitions (such as the annual Indian Art Market in Santa Fe and the Navajo Craftsman Show at the Museum of Northern Arizona) have presented the best of these works to the public and have brought the artist and the consumer together, providing a meeting place as well as a market. The consumer, now almost entirely non-Indian, is instrumental in performing several roles: supplying the economic base upon which all of the weaving efforts are based; maintaining the pride of the weaver by appreciation of her work, praise for her skills, and encour-

agement for her experiments; and commissioning works, which with good taste continues to improve the art. Without this complex, involved collaboration, it seems quite probable that the weaver's world would have unraveled long ago, leaving only a faded fragment of what was once an important activity.

The Navajo weaver has enthusiastically responded to this new sense of self-worth, as well as to the increased cash income that has resulted. However, as any creative artist is well aware, the economic return, even though a critical factor, is not in itself sufficient reward for the tedium of any craft work; there must be a personal sense of pride and self-fulfillment as well. These have worked well together to provide an atmosphere of achievement and respect that has resulted in the quality of design and technical skills so evident today in Navajo weaving.

Out of this background, then, have emerged the results of countless experiments, successes, and failures of the Navajo weavers today. For not every woman is a fine weaver; many who occasionally toil at the loom are plodders, so to speak, producing only average, repetitive textiles. But there can be little question in any survey of contemporary Navajo weaving that the successes have completely overshadowed the failures. For it is the thesis of *Song of the Loom* that today's weavers produce textiles of a quality of design and technical execution that are in every way equal to and in some instances even better than the work of their grandmothers.

For sheer fineness of weave, the contemporary artists of Two Grey Hills, whose work often yields thread counts of 110 and 120 per inch, have never been surpassed; but it is the skill of the women who enjoy the difficult challenge of the so-called Chant Weaves which is so remarkable. In devising technical solutions for weaving the complicated patterns and creating the myriad details—especially the circles, which are so difficult in the angular crisscross loom grid—they have gone far beyond the textiles one normally finds in even the best galleries and shops. And in addition to developing the requisite artistic skills, they have had to defy the traditional taboo against permanently reproducing religious designs, while invading what was primarily a masculine preserve. In the White world this crossing of the gender barrier in the professions has been traumatic enough, but in the ultraconservative Navajo domain, where tradition is so rigidly observed, it is an even more remarkable achievement.

Today, the Navajo are the largest Indian tribe in the United States, with a 1985 population estimated at over 170,000 individuals, inhabiting a reservation of approximately 160 million acres in Arizona and New Mexico. In 1973 a census of weavers recorded 28,000 women who knew how to weave. How many were regularly producing textiles is not recorded; a fair guess would probably place the total between 5,000 and 7,500 (Roessel, 1983: 596). And, although the number of textiles per capita may have declined slightly, this seems most likely due to the fact that the weavers take more pains with their work in response to the demand for higher quality, thereby producing fewer

examples, but for which they are far better paid. Reliable figures on the total cash income are almost nonexistent; the 1973 census recorded a total of $2,799,232 spent by traders for rugs. The amount paid for weaving is undoubtedly far greater today, but this is due in large part to the higher prices of the textiles, as well as the increasing competition among collectors for prize specimens.

This is a necessarily simplified account of a complex, deeply interwoven history out of which has emerged today's Navajo textile industry—for it is truly an industrial phenomenon, however dispersed—and one, moreover, that is still under the profound influence of an outside world. It a strong fabric, to be sure, but one supported by a very fragile thread.

TWO

SONG
OF THE
HATALI

THE
RELIGION

The textiles in *Song of the Loom* comprise a diversity of styles, but one might fairly say that the heart of the selection is its array of designs derived from the religious life of the weavers. Indeed, the largest group of textiles in the exhibition consists of a comprehensive selection of so-called Chant Weaves, which are relatively accurate reproductions of the sand-painting designs that form an important part of the Navajo ceremonies. Even though they may intentionally or inadvertently vary somewhat from the orthodox designs, they are still faithful reproductions and, as such, provide a rare permanent record of ritual art. Although none of these textiles is intended for Navajo use (and they were in fact made to meet the needs and interests of the outside purchaser), they do reveal facets of the weavers' interest in their own religious art.

The religious life of the Navajo people, while complex in organization, practice, and paraphernalia, has a relatively simple central core: the purification, curing, and treatment of the mind and body of the individual and the society. While accomplished in varying ways, all of the ceremonies are dedicated to the elimination of sickness and evil and to the establishment of tranquility and harmony in their place.

Beyond theological doctrine, the goal of the religious practices of the Navajo differs from the Christian primarily in being far more pragmatic, concerned more with the present needs of the people than with a vague hereafter. In this regard, they are also somewhat different from other Indian groups, many of whom have a strong sense of another world after death.

To accomplish their goals, a trained priesthood conducts formally prescribed ceremonies which are performed in private or in public, depending upon the circumstances. The enormous number and complexity of the ceremonies mean that no one person could remember all of the details of all of the rites; accordingly, the individual leader (or priest, in effect), known as a *hatali*, will usually be a specialist in a given major ceremony or group of observances. Some of these occupy up to nine days and are accompanied by as many as forty complicated sand-painting designs, songs, prayers, and rigidly established formulas, and thus pose a tremendous challenge to the memory. Moreover, because Navajo

custom dictates that the ritual be perfect in form and execution, there is great mental and physical stress put upon the *hatali*; most of them therefore normally know and use five or six complete ceremonies at best.

A combined concern for mind as well as body is common to most Indian religious practice, but the Navajo carry it to great lengths and can often achieve remarkable results in the curing of a seriously ill individual. To attain or regain a sound, healthy body, the *hatali* offers a multitude of prayers, usually in the form of songs or chants; for this reason he is often referred to as a "singer," and the ceremonies have long been known as "sings" in the non-Navajo world. Because it is important to cleanse the mind and the body before a ceremony is performed, the patient will take a thorough sweat bath to drive out any evil that may be present and to establish a serenity and confidence in which the religious efforts can succeed. To create the necessary atmosphere, the spectators as well as the *hatali* must unite in harmony toward a common good. Visitors, even non-Navajo, are welcome, in the belief that the ritual is for everyone and that "the more the merrier" will achieve the most beneficial results. If the cure is successful, everyone who has participated in the affair is likewise blessed and departs from the ceremony with a feeling of purification and soul renewal. Even if no immediate cure can be discerned, the benefits of the group efforts are felt to bring comfort and a sense of well-being.

The preparations required for a Navajo ceremony fall upon all who participate. The *hatali* must carefully observe many restrictions and demands upon his daily life: continence; abstention from certain foods or activities; mental concentration; the readying of sacred *ketans*, corn pollen, and other substances as offerings to the Holy People; the grinding of sand for the dry paintings; and the preparation of medicines from various prescribed plants and herbs. The patient prepares in mind and body for the rigorous rites. The audience also has obligations: it must approach with the right mental spirit; and it shares the cost of the food, gifts, and payment to the *hatali*, for the Navajo, as always very pragmatic, believe that what is done for nothing is probably worth just that, and the Holy People will be offended if proper payment is not provided. Payment can be made in food, objects, and, in today's economy, cash. Bearing in mind that often two or three hundred people can be involved in an important ceremony, the cost of curing is no less expensive in Navajo society than in the White world. Most ceremonies are held for a single patient; occasionally several persons may be treated at the same time.

Once everything is gathered together and the people are in place, the *hatali* begins the ceremony, which may be held privately within the *hogán* or out in a cleared area nearby. He will usually have one or more assistants, not unlike the interns aiding a surgeon. Chants, prayers, and ritual observances accompany the creation of the first of many sand paintings, made with finely ground minerals and sands selected for their color as well as for their source. These are usually stored in small buckskin pouches until used.

The earth surface is cleansed and smoothed prior to the actual painting. Then the *hatali*, with his apprentices, begins the tedious process of drawing the prescribed designs. Taking a handful of pigment, the painter carefully pours it between thumb and finger in a fine line; he repeats the process until the design is completed. During the painting, prayers will be sung as the need requires, and the people gathered around will unite in good thoughts.

Sand-painting designs follow a standard pattern. There is usually a red-blue-and-white band—circular, rectangular, or occasionally diamond-shaped—that surrounds the inner motifs and in most designs has an opening on one side. This represents the Rainbow God, who is hermaphroditic; the red band is male, the blue female, and the white unites them. The opening, known as the Rainbow opening, invariably faces the east. Within the protective circle are many supernatural beings who have a role in the ceremony; these represent the deities and sacred features or geographical places of the Navajo world. (There are far too many to list in this brief section, but among the major deities are the Humpback God, *Ga'askidi*; the Monster-Slayer God, *Nayénezgani*; and the Talking God, *Hashchyelti*. These are identified in the Glossary, *q.v.*) Although their placement is somewhat up to the *hatali* and his assistants, they must be included in the design for it to be effective. Artistic interpretations of these Beings will differ slightly from individual to individual, but they are sufficiently standard as to be recognizable to anyone familiar with the ceremony.

Designs are usually bisymmetrical or quartered, and may be viewed from any angle, although the correct way to see a sand painting is with the Rainbow opening directed toward the east. To protect the design and the patient, several guardians are placed at strategic points, usually at the Rainbow opening. The most common guardian is *Dontso*, the Messenger Fly, who often guards the opening in pairs to keep the evil forces out and to protect the beneficial powers that are inside.

Once the painting is completed, the patient will be placed in the center so as to absorb the holiness in the designs. Sacred corn pollen and sand from the painting will be sprinkled over the patient, and prayers and chants to strengthen the ceremony will accompany the physical activities. With the last prayer, the patient rises, and the *hatali* and his assistants begin to scoop up the sand from the design. The painting has accomplished its purpose of imparting the beneficial curing properties of the design while absorbing much of the illness that afflicted the patient, and so it must be destroyed, for it no longer has any healing power (indeed, with the absorbed evil from the sick body, it is very dangerous). Often the spectators will sprinkle a bit of the sand upon themselves wherever there is a need—perhaps to ease a stiff joint or soothe an aching muscle—and then the gathered sand is deposited outside of the *hogán* area, to be scattered by the winds.

If the ceremony is one at which the Gods are expected to appear publicly, this usually takes place outside the *hogán* and normally includes eight to twenty-four dancers costumed and masked to represent the various *Yei*. They dance in an established pattern and rhythmic step; the male and female couples form two long rows, side by side. Their songs vary with the ceremony and the particular Being; they do not talk but convey their meanings by gestures interpreted by the *hatali*. Each has certain

specific mask and costume designs by which the Being is identified, and it is these visual features which are so important in the sand paintings. With the completion of the ceremony and the departure of the *Yei*, the ritual ends. The form is traditional but not fanatically rigid; it may be abbreviated or elaborated as time and finances dictate. Navajo religion is comfortable and comforting; it is not stifling.

This is an extremely condensed, even oversimplified account of the *Yeíbichai*, as the performance is popularly called; but it will give a sense of how the sand-painting designs fit into the religious life of the people. They are an integral part of all ceremonies and provide a central focus for the event, for they are a place for the Gods to gather invisibly and work their beneficial powers, as well as an arena in which the forces of evil that have afflicted the patient are fought with and driven out.

These designs are therefore powerful holy works that must be treated with caution. Earlier, they were not even sketched or drawn (let alone replicated in textiles); they were far too dangerous for any but the *hatali* to deal with. But little by little, the religious strictures eased, and scholars were able to get the more liberal leaders to allow the recording of ceremonial designs; gradually, as published reproductions of the designs became more common, the feeling of sacrilege also lessened markedly.

But the reproduction of the designs in textiles was only occasionally ventured, and such departures from tradition were very few and far between, undertaken with considerable trepidation. However, when none of the weavers suffered the feared consequences of blindness, illness, even death, as had been widely warned, some of

the braver weavers increasingly used *Yei* designs in their work. One of the earliest individuals to take this radical step was Hosteen Klah, undoubtedly the best known and most influential; his work, starting about 1919, left an indelible mark.* Because he was a medicine man, he was believed to be able to ward off any evil effects. Through his own weaving and the work of his two nieces, Hosteen Klah paved the way for the art as we know it today (Newcomb, 1964). In time, an even more daring step was the replication of sand paintings for commercial purposes, produced in colored sand and mounted on wood or Masonite panels. This has become a widespread, popular craft product within the last twenty years or so, although there were a few experimental works done in the late 1940s. Today, almost every sand-painting design has been duplicated (in reduced size) in one form or another for commercial sale or purposes of preservation (Parezo, 1983). Yet the point should be stressed that even with this modern sense of liberty from rigid formula, the weavers and sand painters are usually careful to change their designs slightly, leaving out a feature here or a detail there so as not to risk offending the dangerous power of the deities.

Although the economic factor may have been a strong influence, probably two other factors account even more importantly for this willingness to record the designs permanently: the fact that nothing happened to

*McGreevy, quoting Coolidge, says his first work was in 1910. I believe this is a misprint for 1920 (McGreevy, 1983; n.p.). As to the question of male weavers, although it is unusual, it is not unknown in Indian life for men to work in a craft that is usually assigned to women. These men are usually accepted as being "different" and, while they are not particularly respected, they are not ostracized.

those who ventured into the dangerous area, and a recognition of the value of preservation by documents. It is not uncommon to find a copy of one or more of the major books on sand-painting designs in the *hogán* of a medicine leader, who refers to it just as casually as a priest reads a Bible, or a rabbi the Talmud, for directions or memory support; each realizes that human recall is not infallible. As the total number of sand-painting designs is estimated at around one thousand, one can readily realize how impossible it is to remember them all accurately. In actual practice, perhaps 100 to 150 are in common use.

Today, the number of weavers who regularly use sand-painting designs approaches one hundred, although I am not aware that any specific census has been made. This volume includes thirty-one textiles of this style by seven well-known weavers, plus two early examples by unknown artists. These are the result of a concerted effort to build a collection of top-quality textiles that represent the various stages of sand painting used in the several Chants and that also reflect the remarkable skill which some of the best weavers have achieved in their work.

It should be understood that this collection of textiles is the result of a deliberate and dedicated effort, and in particular one that had the sand-painting and Chant styles as a major focus. Rather than depending upon serendipitous encounter with such textiles from time to time, the collector regularly commissioned certain desired motifs to be woven in his behalf, selecting the best weavers for the purpose. That they have responded nobly is evident in the rich quality of the collection. In this, he was returning to the practices of entrepreneurs such as Hubbell and Moore, when precisely the same thing occurred. Just as those early outside influences contributed to improve weaving today, one hopes that the long-term effect of the present efforts may prove to be equally beneficial.

SONG OF THE WEAVER

TECHNIQUES AND MATERIALS

Although at first glance weaving is in itself a simple over-and-under process, it contains within its interlacing strands an incredible complexity. This must be brought out by the weaver by experimentation, and she often arrives at solutions that have produced some of the most remarkable art objects known.

The Navajo weaver is no stranger to these complexities and, over three to four centuries of development, has given the textile world a wide range of well-produced innovations. Primarily employing a tapestry weave, she has also developed variations, using twill, complementary wefts, special choices of color combinations, and other effective inventions amply demonstrating her skills. In so doing, she has relied upon simple materials: in the early days of her weaving, cotton, which, after the introduction of sheep by the Spaniards, was almost entirely replaced by wool. Although Coronado brought sheep into the Southwest in 1540, they were intended primarily for food; it was not until 1598 and the flocks introduced by Oñate that sheep became firmly established as a resource for both food and wool. Rarely are other fibers used. Although there has been some claim to the use of silk (but only in combination with wool), this seems doubtful; most students feel any such use was probably by a single individual for experimental purposes (Kent, 1985: 36).

The weaving of a textile involves several steps: the shearing of the sheep; cleaning the wool prior to spinning; mixing the dyes and coloring the fibers; and introducing the finished threads onto the loom. Each step is time-consuming but vital to the quality of the finished product.

Spinning is one of the most important parts of the weaving process. The fibers must be cleaned and carded, and then spun on a long spindle; this is given a balance and speed by the use of a disk, known as a whorl. The spindle and disk are almost always of wood; their size will vary with the weight of the fibers. Navajo weavers often spin their wool three or four times to achieve the desired fineness for the best-quality textiles. Spun and respun fibers may be combined in one or more strands, or plies, depending entirely upon how heavy a thread is required. (This is rarely employed in native Navajo weaving, although commercial yarns are often plied.)

After the yarn is spun, the fibers, in skeins, are dipped into the dye; this is an extremely complicated process that involves a considerable knowledge of the flora of the region as well as the specific recipes needed to achieve the desired colors. It should be noted that the use of plant dyes was not a

28

SONG
OF THE
WEAVER

TECHNIQUES
AND
MATERIALS

major resource of the Navajo weavers but was primarily due to the influence of later traders and technically trained individuals. At first probably no more than two dozen plants may have sufficed, but as experiment and exploration increased, the number of such plants used expanded dramatically; one Navajo weaver compiled over 250 recipes (Dutton, 1961: 12).

All Navajo textiles are produced on a vertical loom, as opposed to the horizontal or treadle loom used by European and Mexican weavers and their Río Grande descendants. The loom is relatively simple. Two posts or tree trunks are set vertically, and a top and bottom horizontal bar (loom beams) are firmly lashed to them to establish a rigid frame. To make the two alternate sheds through which the weft passes in weaving plain-weave tapestry, two smaller sticks are used. One (the shed rod) merely passes over and under alternate warps. When it is pulled down, the warps that pass over it are lifted above those underneath. The second stick (heddle rod) is connected by thread loops to the warps passing under the shed rod and, pulling on it, lifts these remaining warps. The batten, a flat, smooth-surfaced stick, is used to help open the shed and hold it open for the weft to be passed through. With this simple device, the Navajo weaver creates the magnificent textiles that we admire today.

The weaver, with her yarn rolled in balls or wound on a short stick, conveniently placed in a basket close to hand, seats herself in front of the loom and begins the process of creating a textile. She starts at the bottom of the loom and proceeds upward, passing the yarn through the warp threads. Once passed, the thread will be firmly packed down by means of the batten (or sword); a fine-toothed, carved wooden

comb (or fork) will be used to pat irregularities into place. With a relatively narrow loom she may complete the passes without difficulty, but when the loom width is such that she cannot reach the sides conveniently, she may construct her field in a way that results in a gradually narrowing area; she will subsequently weave the adjacent area, with the result that there will be a faint diagonal line along the place where the two areas meet and the wefts are turned, creating what are commonly known as "lazy lines." Although some other native weavers occasionally introduce these into their textiles, lazy lines have become almost a diagnostic identification of Navajo weaving.

This is the way in which the major background weave is produced. Small design sections of contrasting color are created by reversing the direction of the weft at the edge of each color area. Where two colors meet, the two wefts may interlock or they may each pass around a single common warp in order to prevent the formation of vertical slits in the weaving.

When she approaches the upper section of the weave as far as she can comfortably reach, the weaver will loosen the work and roll up the finished portion on the lower bar, and then proceed. At the end of the weave, the narrow top section may be finished off by means of a needle to close the narrow gap. The completed textile will be tied off in the corners, and the sides, which have been incorporated into the weaving as it progresses, are secondarily laced with selvage cord to help hold the shape and provide durability. The textile is then removed from the loom, corner tassels may be added, and it is finished.

Such a process may require a week or more of preparation—the gathering of all of the fibers and dyestuffs, and the requisite cleaning, spinning, and dyeing—before the

29

SONG
OF THE
WEAVER
TECHNIQUES
AND
MATERIALS

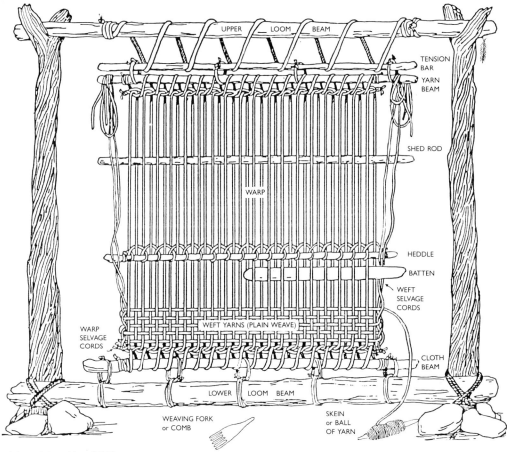

Adapted from Kent (1975)

weaver ever begins the loom work. The actual weaving can require up to several weeks for an ordinary blanket or rug, while a finely woven Two Grey Hills–style textile may take a year to finish. Weaving is not for the impatient.

The method used to achieve the very fine Two Grey Hills weaves is relatively simple, in that it is a basic over-and-under technique, but requires superlative skill, patience, and sharp eyes. The wool fibers used are spun to the dimensions of a fine sewing thread, and the weaving implements often include steel needles. Beyond these concessions to the size of the resultant fiber, little else is different. The greatest requirement remains time itself, for which there is no substitute.

The laborious process of preparation has few shortcuts. Perhaps the most common is the use of commercially spun and predyed yarn or thread, and of commercial dyes. These two save the weaver untold hours and days of preparation, yet many women still

**SONG
OF THE
WEAVER**

TECHNIQUES
AND
MATERIALS

prefer to do their own spinning and dyeing. They feel that the resulting materials are easier to work with, and they have learned that the market is excellent for such products, since many collectors willingly pay a premium for such hand-spun and hand-dyed textiles.

This describes merely the simple tapestry-weave process. There are many variations, such as the recently introduced Raised Outline weave; but perhaps the most intriguing technique in weaving is the ability so amply demonstrated in *Song of the Loom* whereby a skilled artist can weave a circle on a grid pattern. Many of the sand-painting designs depict circular or rounded motifs; in actual practice, other than the development of an ingenious interweaving of finely graded stitching, the Chant styles do not involve any extreme departure from standard practice. The more skilled and patient the weaver, the smoother and more curved will be the resulting forms; such an example is catalogue number 30.

SONG
OF THE
LOOM

THE
PRESENT

From a background of positive and negative factors, periods of affluence and poverty, acceptance and rejection, has emerged today's remarkable textile world. Exhibitions that feature Navajo weaving in the finest art museums are no longer mere ethnological curiosities; books by the dozen have been published on the weaver's art and are quickly snapped up by eager purchasers; and good weavers do not have to haggle with collectors or dealers over prices. Today, high-quality weaves are sometimes sold even before they are removed from the loom, and buyers line up impatiently to acquire the work of some of the best-known artists.

These textiles are no longer lightly regarded room decorations or souvenirs. The finer textiles retail for between $10,000 and $15,000; and $20,000 for an especially fine example is not unknown. Indeed, a typical Daisy Taugelchee or Julia Jumbo fabric (to which Ann Hedlund has given the name "super-fine tapestry," since it is almost the weight of gauze) today readily sells for more than $1,000 per ounce—a very far cry from the old-time rate of 80¢ to $1 per pound.

Naturally, there are imbalances. These high prices are enjoyed only by the very best artists, most of whom have earned a reputation and attracted a stable of collectors; the average weaver today still earns a minimal income from her work, when the time required to gather and prepare the raw materials is taken into consideration. As a result, the total number of women who regularly weave for the market has slowly declined; most young girls are not attracted to the laborious efforts of preparation and the tedium of weaving. At one time, almost every Navajo woman produced a certain amount of woven work, both for home use and for the local trading post. Although much of this was of indifferent quality, weaving was an active industry in which nearly everyone participated. Today, the number of weavers is only a small proportion of the total population; in 1973 about twenty-eight thousand women reported that they knew how to weave, but few of them were working at the loom on a full-time basis (Roessel, 1983: 596). One obvious result of this decline in numbers is that the demand for fine-quality Navajo textiles is far greater than the supply. Any skilled weaver can literally sell everything she can produce, and pretty much at her own price.

An illuminating study was undertaken in 1973 by the Navajo Community College at Many Farms, Arizona, to determine the length of time it took a good weaver to make a rug. The example was a rug of above-average quality measuring about 3 × 5 feet:

Catching and shearing the sheep	1 hour
Cleaning and washing the wool	2 hours
Drying the washed wool	8 hours
Carding the wool	16 hours
Spinning the wool	24 hours
Preparing vegetal dye and dyeing	60 hours
Making and stringing the loom	16 hours
Weaving the rug	215 hours
Brushing, cleaning, and finishing up	2 hours
Selling the rug	1 hour
Total	**345 hours**

The weaver subsequently sold the rug to a local trader for $105—the equivalent of less than 30¢ per hour for her labor (Roessel, 1983: 595).

Even so, she regarded it as "better than doing nothing" with her time. Weaving is often the only source of cash income for many families, with most of their requirements satisfied by barter. Bearing in mind the extremely high unemployment rate of the Navajo people, this hard-won cash may be the only way to obtain those items which many would otherwise have to do without.

Fortunately, there are other rewards beyond the economic for many of the Navajo weavers: the pride of fine artistry and the increased self-dignity it brings, the respect from others, the challenge of achieving excellence, and the sheer pleasure an artist gains from creativity. Any visit with an individual or group of weavers sooner or later will reveal this fact of the enjoyment derived from exercising one's

skills to the utmost, and it is discussed as frequently as how much the weaver was paid for a textile. Furthermore, weavers today do not work in a vacuum; they are often very well aware of museums and publications, and they definitely enjoy having their art appreciated by others.

The outlets for Navajo weaving have also changed considerably. The trader, once the principal and almost indispensable link between weaver and consumer, is fast disappearing as people are becoming more mobile. Most families have pickups, or access to one; they tend to go into town more often; and the large supermarkets have taken the place once held by the trader. Moreover, it should not be overlooked that many entrepreneurs who live in the nearby towns travel out to the weavers' homes, buying textiles directly for subsequent re-sale, thus eliminating the trader as a middleman. And not a few collectors also visit the weavers for the very same purpose, not so much "to beat the price" as for the pleasure of obtaining a treasured piece directly from the artist who created it.

With increased mobility, the availability of books and printed illustrations, exposure to television, and increasing visits by outsiders, it is surprising how constant Navajo textile designs have remained. It is perfectly true that many weavers copy designs from various sources, including book and magazine illustrations and the work of weavers in other areas of the reservation, and that there are subtle influences discernible in the contemporary output. But in general, the weavers tend to continue in a fairly standard manner, following the patterns of their mothers or their own long-time style; and when they do copy other motifs, it is almost invariably done in a form that retains the integrity of the style. In short, while changes do occur, the result can still be readily identified as a Navajo product by its

design characteristics without having to resort to technical analysis.

The more dramatic changes have tended to follow the time-hallowed Navajo custom of slow but steady practice, the introduction of motifs or elements on an experimental basis until they become accepted—and thereby traditional. The most outstanding example of a relatively recent innovation has been the Raised Outline style, which apparently was a joint invention of Navajo weavers in the Coal Mine Mesa region, working with Ned Hatathli during the late 1940s, and seems not to have had any outside influences.

In part, experimentation is the natural result of any capable artist pressing her skills to the limit, perhaps simply "to see if she can do it," as has been said. But others continue to be responsible for innovations, notably dealers and collectors who are especially intrigued by differences, and, not incidentally, non-Indian artists, who have upon occasion sketched design elements for weavers to employ in their work. Just as the earlier influences of Moore, Hubbell, Cotton, and others have resulted in historic developments, so have the more recent innovators. Some of these introductions may survive; others will probably be short-lived; but all will have some degree of influence upon the weaver.

The dramatic increase of such "new" products as the *Yeíbichai*, *Yei*, sand-painting, pictorial, and fine-weave textiles (and, even more recently, super-fine weave miniatures) is the result of economic dynamics at work and in fact reflects a long period of development. None of these is made for Navajo use; they are intended for White consumers and collectors. The greatest effect has been in the number of textiles woven, rather than in important changes in style or design. Whereas earlier a *Yei* or Chant design was something of a rarity,

now it is commonplace. Pictorials were made by a few specialists and seen only occasionally; they are still somewhat scarce, due to the technical demands involved, but they are far more frequently found in shops and galleries than formerly.

What is new in the contemporary market is the attention paid to the interests of collectors, whose number has grown enormously. Earlier, the consumer tended to buy whatever was available, selecting on a basis of quality, design, taste, and price. Today, it is not unusual for a person to commission a weaver to produce a specific style, design, or weave, with the confidence that the result will be as ordered. This is the genesis of most of the Chant-style textiles that form the core of the present exhibition.

The Navajo tribe itself has taken steps to strengthen the interest of weavers in continuing their art, both as a measure of pride and for the economic benefits involved. There seems little likelihood that Navajo weaving is in danger of dying out, as was once feared. It will, on the contrary, thrive so long as there is a definable Navajo culture, a receptive audience, a knowledgeable understanding of what the art represents, and an adjustment to the varying economic requirements of any handcrafted art. There seems to be a dedicated number of women who find many rewards in weaving—personal, social, esthetic, and psychological—far beyond the economic. And so long as these continue, so will the strength of the art.

CATALOGUE

Basic information concerning each textile is presented for the following categories. For further definitions of terms, see the Glossary.

WEAVER is identified by name when known; some errors may exist, most particularly where a few weavers have two names, although great care has been taken to identify the individual weaver as accurately as possible.

LOCALE refers to the present home of the weaver. Because many of these women work in several styles, this may have little reference to their work.

DATE of weaving for each work is a difficult problem, since many of these textiles were obtained without documentation as to when they were made. A best-judgment date on the basis of style, weave, and design is given; historic specimens can only be estimated. Most of the contemporary weaves are dated to the year in which they were acquired by the collector; in most cases, these would have been woven not more than a year before that time, and many were purchased directly after completion.

STYLE refers to the generally accepted name for the visual type of design.

FUNCTION relates to the use or the purpose of the textile insofar as can be determined by size, weave, and design type.

MATERIAL is wool in all examples, although a few cotton-warp examples are included; commercial or hand-spun yarn is indicated if known, as is vegetal or commercial dye.

SIZE is given in inches, *length* and *width* as loomed; it is manifestly impossible to establish exact measurements for a large hand-woven textile; therefore, a one-half-inch range has been arbitrarily adopted.

YARN COUNT represents an actual examination by the collector, and was calculated by counting the number of warp threads and the number of weft threads in one square inch of each textile: *warp* × *weft*.

I

WEAVER	Unknown
LOCALE	New Mexico
DATE	ca. 1860–70
STYLE	Serrated design
FUNCTION	Wearing blanket
MATERIAL	Hand-spun yarn
LENGTH	73½ inches
WIDTH	47 inches
YARN COUNT	13 × 74

A classic tightly woven blanket of the period following the return of the Navajo from Bosque Redondo, this is the common style of the body garment of the period just after the U.S. Civil War. It features the black, white, and indigo zigzag-and-diamond motifs on a red background derived from the *serape* garments of the region around Saltillo, Mexico.

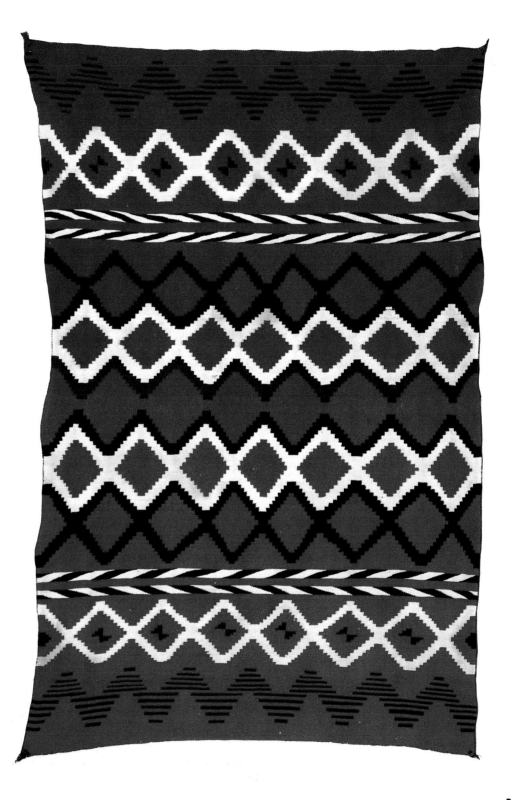

2

WEAVER	Unknown
LOCALE	Ganado, Arizona (?)
DATE	ca. 1880
STYLE	Moki
FUNCTION	Floor rug
MATERIAL	Hand-spun yarn
LENGTH	80 inches
WIDTH	55 inches
YARN COUNT	11 × 52

A typical weave of a design favored by Lorenzo Hubbell, this is a tightly woven textile that apparently originated in the Ganado area toward the end of the last century. The term *Moki*, referring to the Hopi, is inaccurate; although there is a Pueblo prototype that may have influenced the design, almost all Moki textiles of this type were woven by Navajo women.

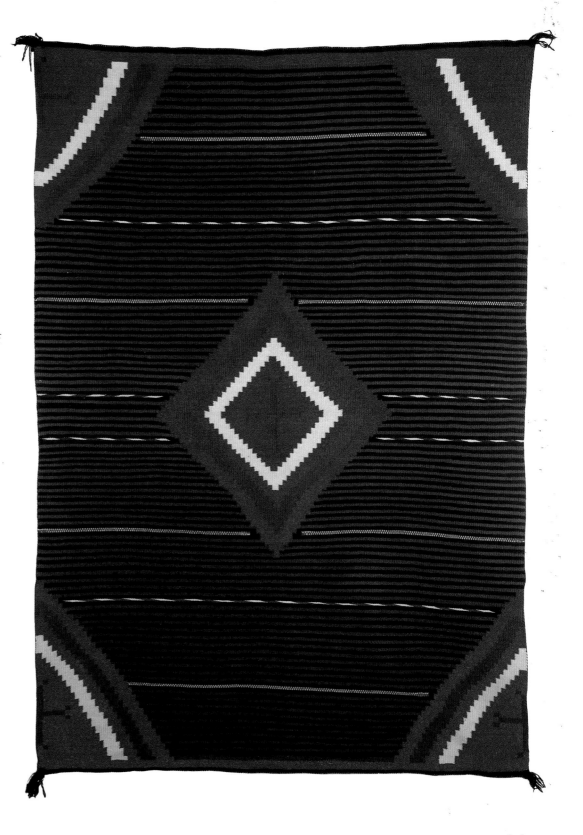

3

WEAVER	Unknown
LOCALE	Ganado, Arizona area (?)
DATE	ca. 1890
STYLE	Eye Dazzler
FUNCTION	Wearing blanket
MATERIAL	Germantown yarn
LENGTH	88½ inches
WIDTH	54½ inches
YARN COUNT	8 × 40

This is a classic-style *serape* design with a
Ganado red background and finely woven repeat
diamond-and-star cross patterns. This is the
epitome of turn-of-the-century magnificence,
with its vibrant color and precise weaving.

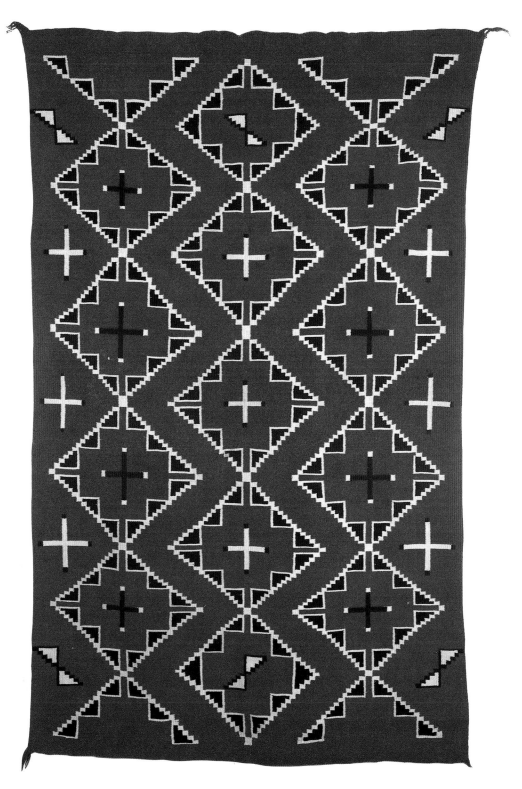

4

WEAVER	Unknown
LOCALE	Ganado, Arizona area
DATE	ca. 1890–1910
STYLE	Ganado
FUNCTION	Fancy saddle pad
MATERIAL	Hand-spun and Germantown yarn
LENGTH	24½ inches
WIDTH	25 inches
YARN COUNT	11 × 32

Also known as "Sunday Saddle Blankets," these were not for everyday use but were reserved for special occasions. The pad was arranged beneath the saddle so that the elaborate multicolored fringe and tassels would show to best advantage. *(See also nos. 5 and 6.)*

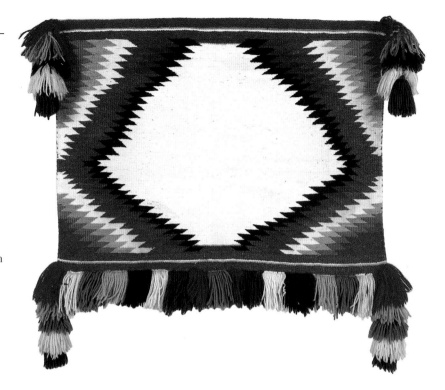

5

WEAVER	Unknown
LOCALE	Ganado, Arizona (?)
DATE	ca. 1890–1900
STYLE	Ganado
FUNCTION	Fancy saddle pad
MATERIAL	Germantown yarn
LENGTH	36½ inches
WIDTH	25½ inches
YARN COUNT	13 × 54

A turn-of-the-century Sunday Saddle Blanket, this is an especially fresh design. The brilliant colors and zigzag diamond motifs make it a beautiful demonstration of the weaver's skill. *(See also nos. 4 and 6.)*

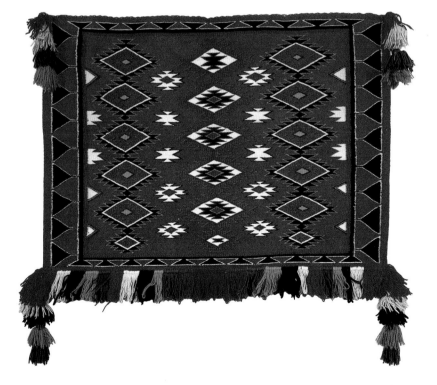

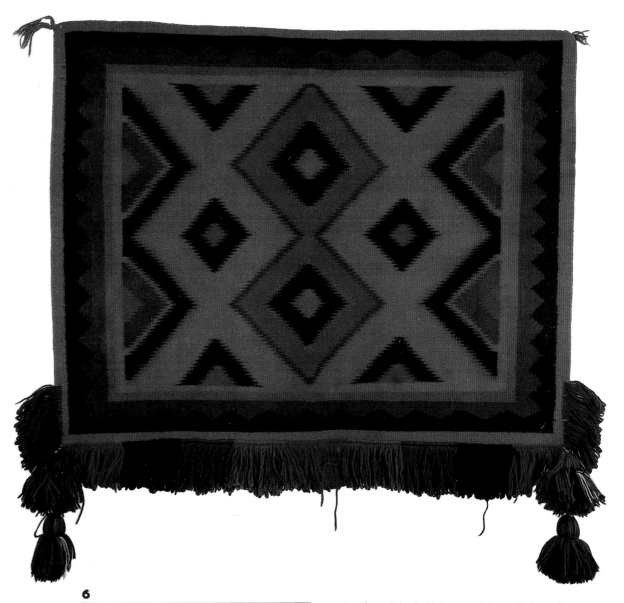

6

WEAVER	Unknown
LOCALE	Ganado, Arizona
DATE	ca. 1890–1910
STYLE	Ganado
FUNCTION	Fancy saddle pad
MATERIAL	Germantown yarn
LENGTH	33 inches
WIDTH	25½ inches
YARN COUNT	13 × 44

Another of the bold-design, elaborately fringed textiles, this is remarkable for its condition and strong design. Although commonly called a "double weave," this is not technically true; it is simply a tapestry weave made from a heavier-spun yarn that provides a much thicker texture than normal. These are increasingly rare today, due to the hard wear given them and to the decreasing use of the horse. *(See also nos. 4 and 5.)*

WEAVER	Dorothy Dee
LOCALE	Tees Nos Pos, Arizona
DATE	ca. 1984
STYLE	Eye Dazzler
FUNCTION	Floor rug
MATERIAL	Commercial yarn
LENGTH	72½ inches
WIDTH	49½ inches
YARN COUNT	9 × 42

Eye Dazzlers have not disappeared; they simply take on a new life. This is a recent example of the old form, with the bold colors, sharp detail, and contrasting designs that created the name, but with the strong zigzag diamond pattern typical of one form of Tees Nos Pos design.

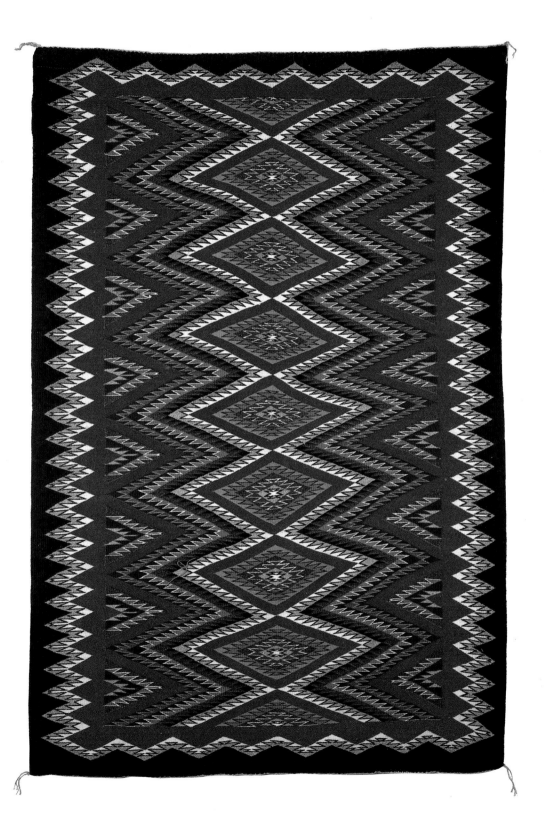

8

WEAVER	Unknown
LOCALE	Ganado, Arizona area
DATE	ca. 1890
STYLE	Eye Dazzler
FUNCTION	Wearing blanket (?)
MATERIAL	Germantown yarn
LENGTH	97 inches
WIDTH	72 inches
YARN COUNT	9 × 42

With strong influences from *serape* designs, but of a size suggesting possible use as a floor rug or wall hanging, this transitional example is a riot of magnificent color and demonstrative of exceptional weaving skill.

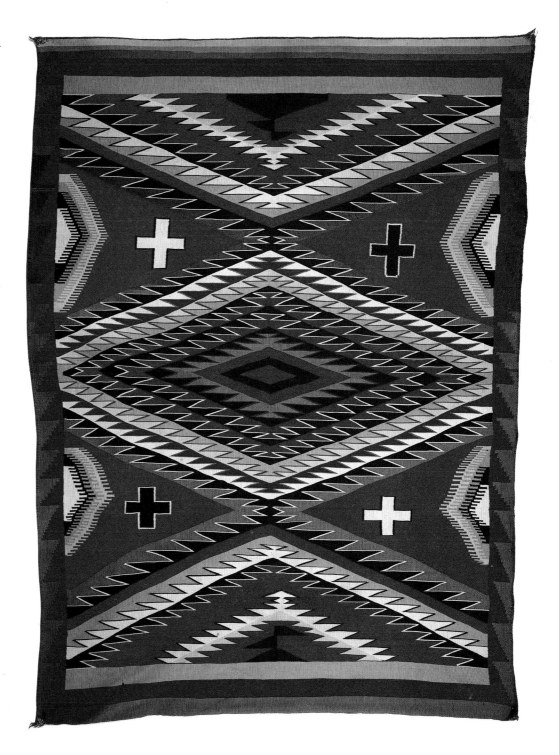

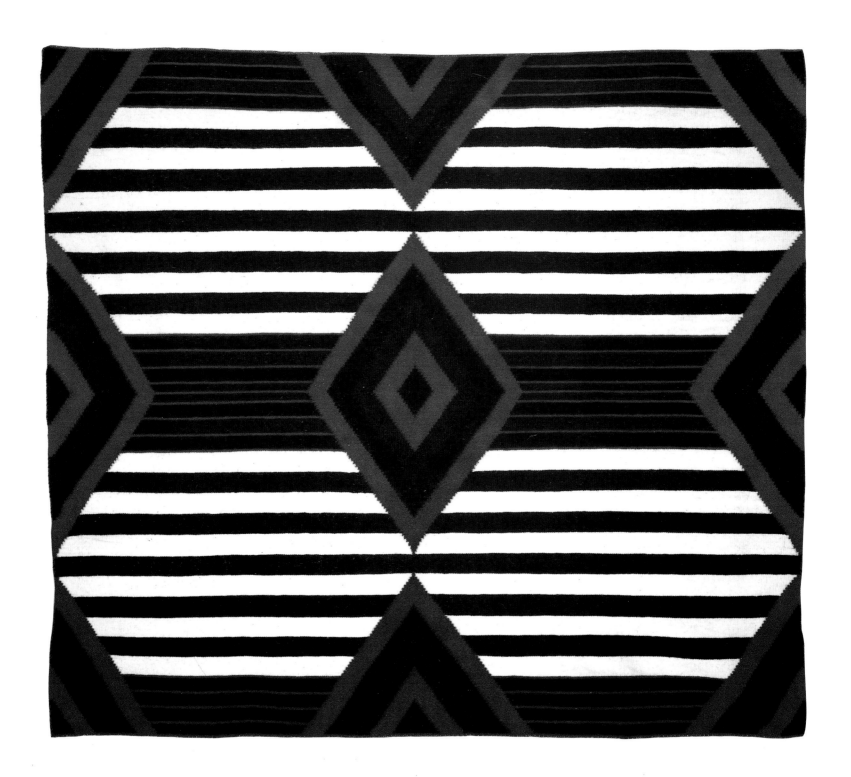

9

WEAVER	Mrs. Mike Keyonney
LOCALE	Ganado, Arizona (?)
DATE	ca. 1963
STYLE	Chief's Blanket
FUNCTION	Floor rug
MATERIAL	Hand-spun yarn
LENGTH	60½ inches
WIDTH	53½ inches
YARN COUNT	12 × 56

This fine recent example of the Chief's Blanket design, of the so-called Fourth Phase (determined by the nine very large triangle-and-diamond indigo-and-red forms), suggests that classic old motifs remain popular with weavers as well as with consumers. This textile is no longer intended to be worn as a blanket but is now for use on the floor.

10

WEAVER	Sarah Yazzie
LOCALE	Crystal, New Mexico
DATE	ca. 1980
STYLE	Chief's Blanket
FUNCTION	Floor rug
MATERIAL	Commercial yarn
LENGTH	62 inches
WIDTH	43 inches
YARN COUNT	11 × 38

A modern adaptation of the familiar Chief's Blanket motif, this design is well within the Ganado tradition, with strong geometric black and white motifs on a vibrant red background, divided into three zoned sections—clearly a textile that would have pleased Lorenzo Hubbell. Today these are popularly called "Christmas Tree rugs."

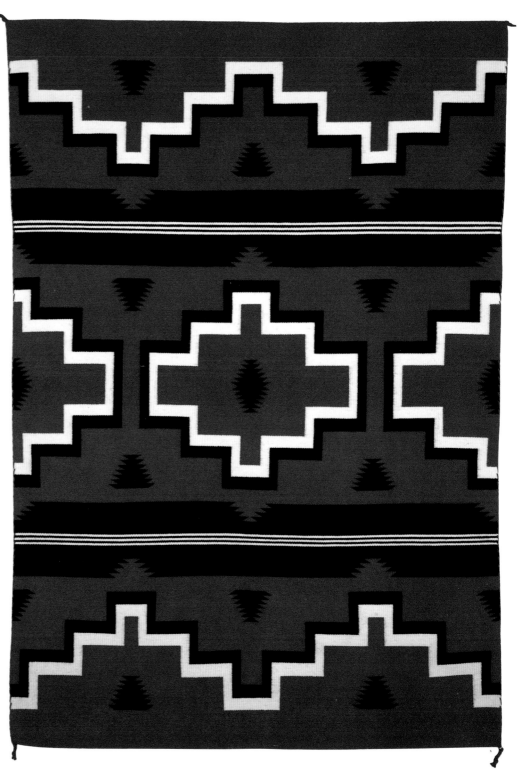

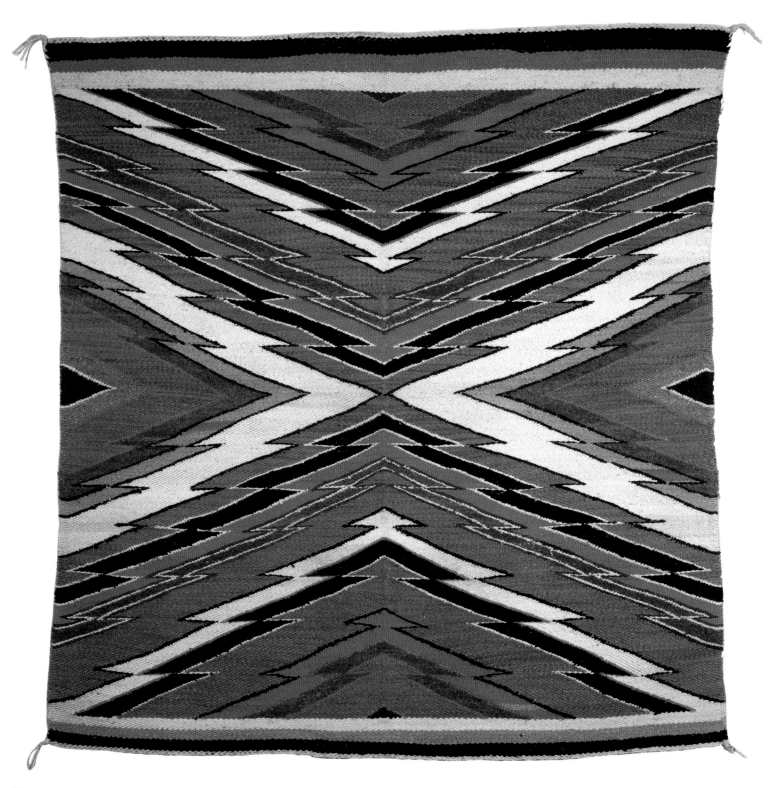

11

WEAVER	Dorothy. Francisco
LOCALE	Four Corners, Arizona
DATE	ca. 1983
STYLE	Serrated design
FUNCTION	Saddle pad or throw rug
MATERIAL	Hand-spun yarn
LENGTH	57½ inches
WIDTH	54½ inches
YARN COUNT	6 × 18

An unusual almost-square, loose-weave textile, this has a wrapped wool warp—a rare example of a little-used technique. The large, dominant zigzag X motif, sometimes termed St. Andrew's Cross, is reminiscent of Saltillo patterns.

12

WEAVER	Unknown
LOCALE	New Mexico
DATE	ca. 1880
STYLE	Multi-pattern sampler
FUNCTION	A floor rug; perhaps a catalogue?
MATERIAL	Germantown yarn
LENGTH	107½ inches
WIDTH	68½ inches
YARN COUNT	10 × 38

One of several multi-pattern textiles whose purpose and origin are unknown, this example is quite early for the type. They are usually quite large. The "Biggest Navajo Rug in the World," woven in 1978 and measuring 25 by 38 feet, is of this design.

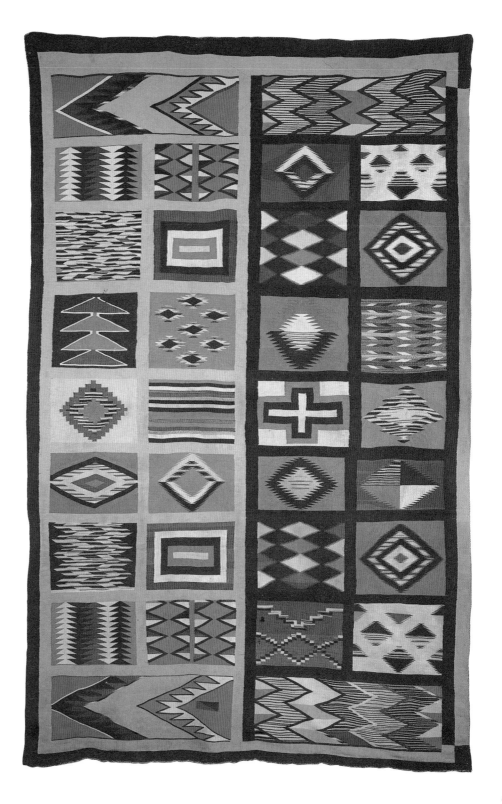

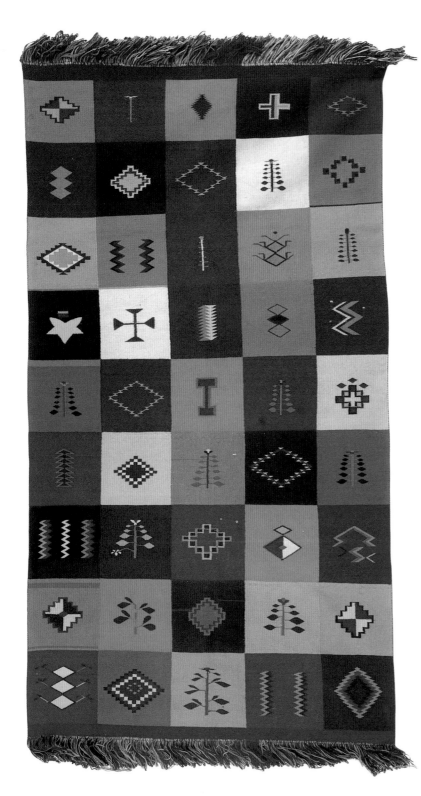

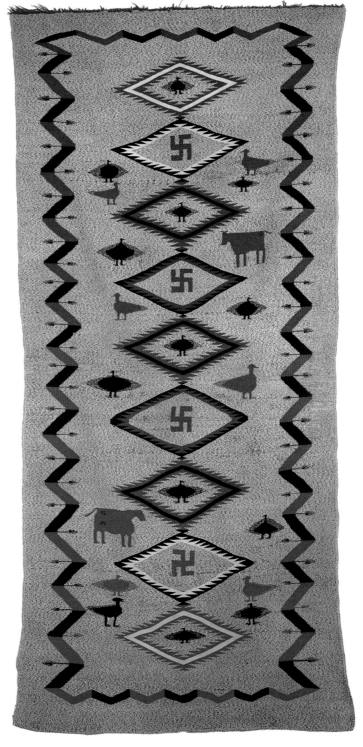

48

13

WEAVER	Unknown
LOCALE	New Mexico
DATE	ca. 1880
STYLE	Multi-pattern sampler
FUNCTION	Wall hanging
MATERIAL	Germantown yarn
LENGTH	86½ inches
WIDTH	47½ inches
YARN COUNT	12 × 48

This is a fine old multicolored sampler with a different design in each of the forty-five squares. Whether these were intended as visual references or are simply a show-off approach to weaving is uncertain; they seem to have been very popular at the turn of the century and are being actively revived today.

14

WEAVER	Unknown
LOCALE	New Mexico
DATE	ca. 1890–1900
STYLE	Pictorial
FUNCTION	Floor rug
MATERIAL	Germantown yarn
LENGTH	90½ inches
WIDTH	41 inches
YARN COUNT	12 × 46

This early design incorporates pictorial elements in a basic *serape* pattern. The inclusion of nineteen birds, two cows, and four swastikas (traditional Indian motifs) clearly shows the weaver's response to White consumer expectations.

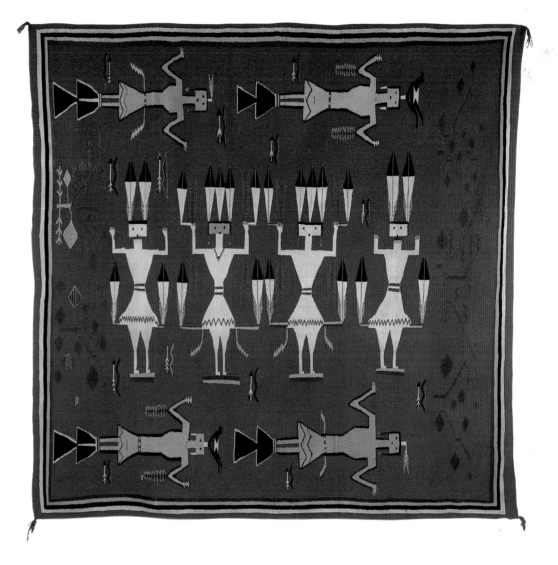

15

WEAVER	Unknown
LOCALE	New Mexico
DATE	ca. 1880–90
STYLE	*Yei* design
FUNCTION	Floor rug or wall hanging
MATERIAL	Germantown yarn
LENGTH	98½ inches
WIDTH	96½ inches
YARN COUNT	11 × 40

Unusual for the solid red background, this is an early *Yei* design, with the Holy People standing on Rainbow bars. There are four sacred plants (two on either side) and four *Yeiba'ad* on clouds (two each on top and bottom), within a solid double-band border. The weaver has taken considerable liberties with this design—a common practice with early adaptations of taboo subjects. The banded border, ostensibly a Rainbow, is simply four parallel lines.

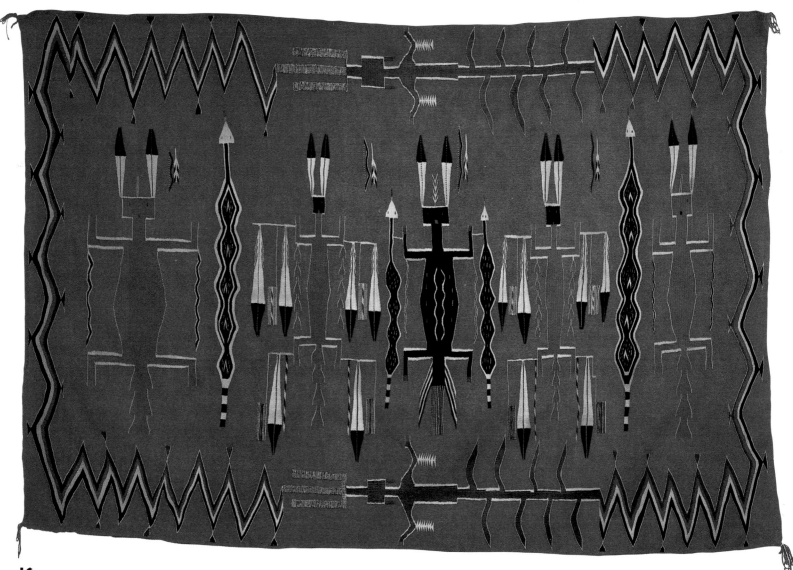

16

WEAVER	Unknown
LOCALE	Probably Lukachukai/Greasewood, Arizona Area
DATE	ca. 1890–1900
STYLE	*Yei* design
FUNCTION	Wall hanging
MATERIAL	Germantown yarn
LENGTH	98 inches
WIDTH	66 inches
YARN COUNT	10 × 42

A remarkable early *Yei* pattern, and unusual for the solid red background, this portrays five vari-colored *Yei* figures in an astonishing abstract form. Two large Black Snakes separate the major figures; the central *Yeiba'ad* has two smaller snakes suspended from her arms. An old type of abstract feather symbol is also extensively used. The border is not a Rainbow, but a three-lined zigzag "lightning" form, attached to two Corn People.

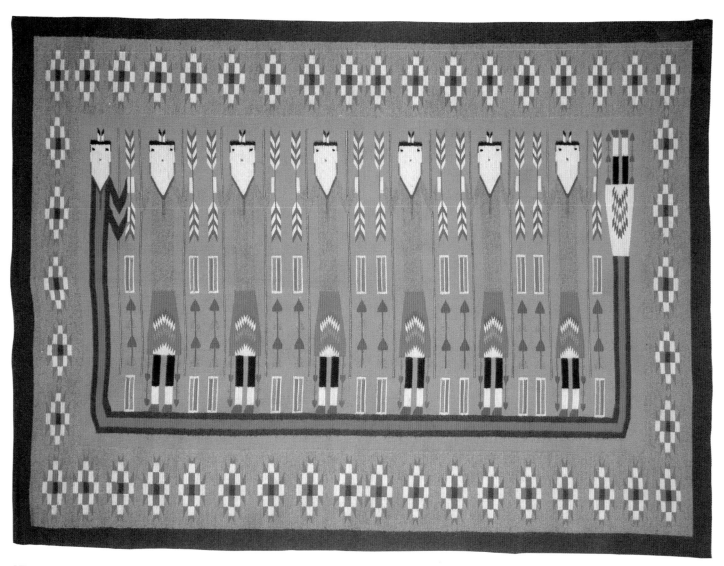

17

WEAVER	Nellie Nelson
LOCALE	Lukachukai, Arizona
DATE	ca. 1982
STYLE	*Yei* design
FUNCTION	Wall hanging
MATERIAL	Vegetal-dyed hand-spun yarn
LENGTH	87 inches
WIDTH	64½ inches
YARN COUNT	10 × 36

This tightly woven textile is a blanket-within-a-blanket. The outer design features a repeated geometric motif of white, brown, and ocher against a grey field, while the central design uses the same colors to depict six *Yei* and a Rainbow God on an ocher field. With fewer figures and softer color combinations, this is not as clashing to the eye as no. 21, which it resembles, yet it is equally effective as a design.

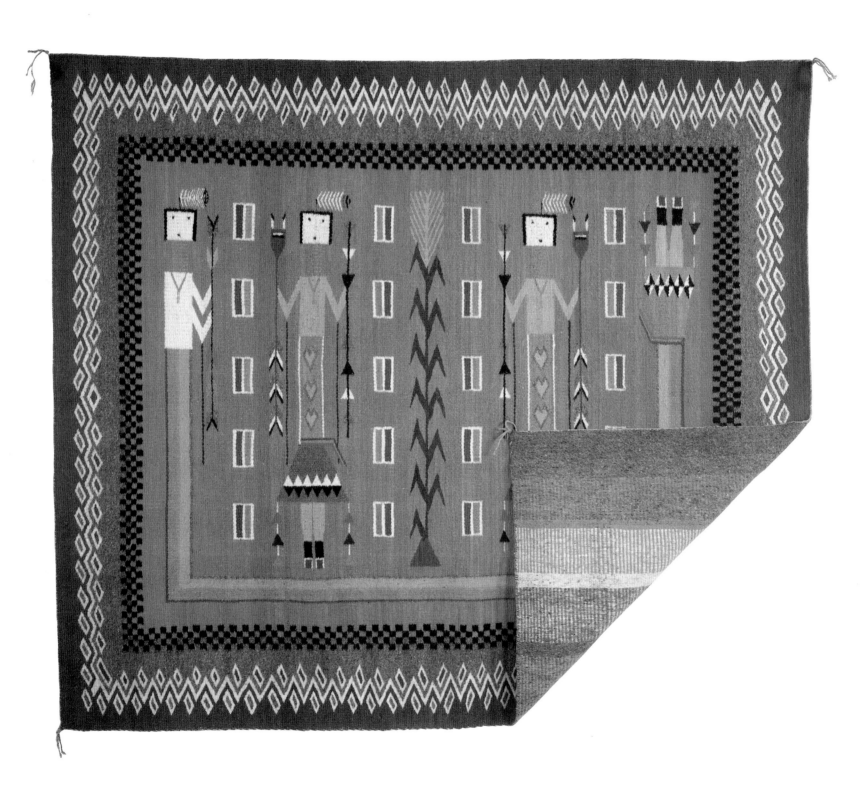

18

WEAVER	Audrey Wilson
LOCALE	Ganado, Arizona
DATE	ca. 1976
STYLE	Two-faced design
FUNCTION	Wall hanging
MATERIAL	Hand-spun yarn
LENGTH	70 inches
WIDTH	60 inches
YARN COUNT	7 × 24

This is an excellent example of a complicated *Yei* pattern on one side, with a plain band reverse. This is the most complex two-faced weave in the exhibition; most textiles of this kind are simpler in design, usually created in rows of multiple bands or squared elements. *(See nos. 22 and 23.)*

19

WEAVER	Suzy Black
LOCALE	Lukachukai (?), Arizona
DATE	ca. 1965
STYLE	Pictorial
FUNCTION	Wall hanging
MATERIAL	Hand-spun yarn
LENGTH	113½ inches
WIDTH	72½ inches
YARN COUNT	8 × 30

A very famous pictorial textile that has been published several times, this zoological *tour de force* depicts animals and birds in relatively somber black, brown, and grey tones against a black-and-white background of serrated patterns. The overall treatment is reminiscent of Mexican Indian designs, which frequently feature floral and faunal motifs.

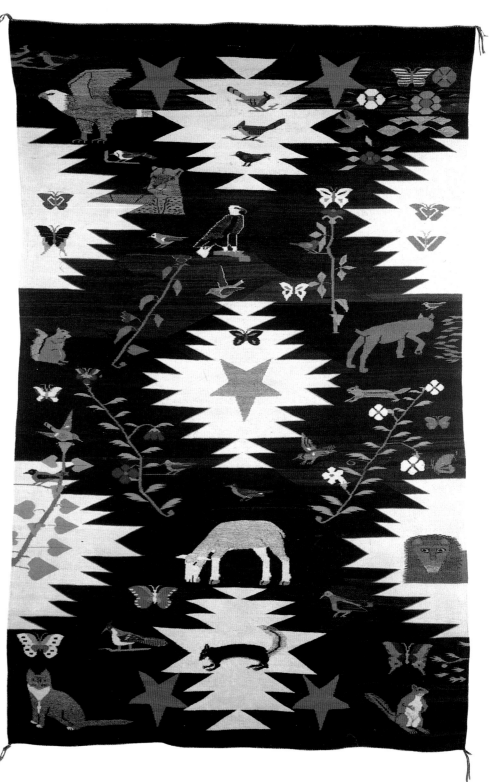

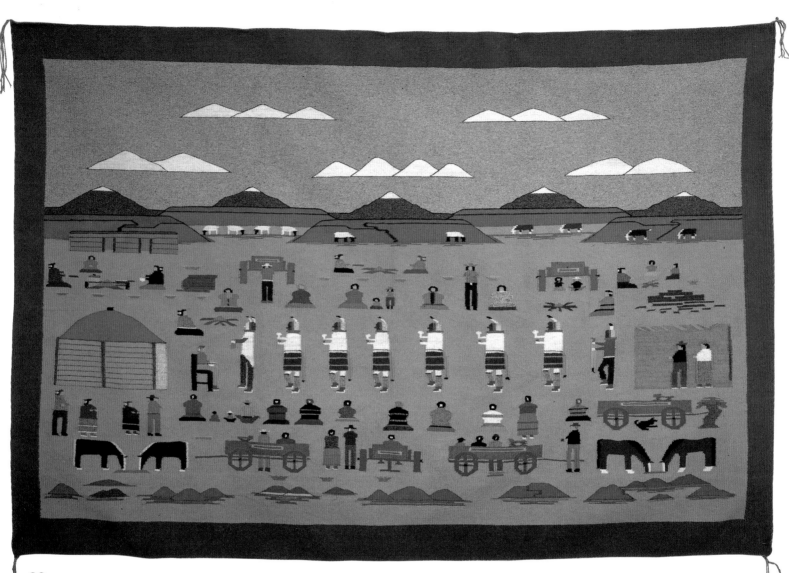

20

WEAVER	Laura Nez
LOCALE	Four Corners, Arizona
DATE	ca. 1983
STYLE	Pictorial
FUNCTION	Wall hanging
MATERIAL	Commercial yarn
LENGTH	81 inches
WIDTH	54½ inches
YARN COUNT	11 × 38

This is a fine demonstration of the extent to which weavers have been able to pursue realism. While such examples have no place in traditional Navajo life, this does not detract from its quality as an art object. The scene is a *Yeíbichai* ritual in progress; the *hatali* and masked *Yei* dancers are evident, as are the spectators, their wagons, flocks, cattle, and *hogán*, all gathered for a ceremony. This is a tableau typical of almost all *Yeíbichai* ceremonies.

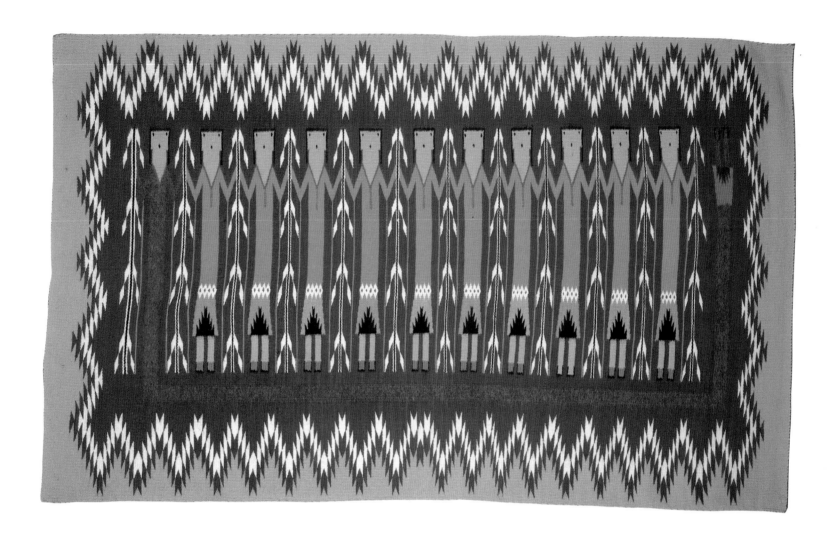

21

WEAVER	Helen Burbank
LOCALE	Chinle, Arizona
DATE	ca. 1982
STYLE	*Yei* design
FUNCTION	Wall hanging
MATERIAL	Vegetal-dyed yarn
LENGTH	73½ inches
WIDTH	44½ inches
YARN COUNT	8 × 32

This intricate variation of the Eye Dazzler integrates ten *Yei* figures into its overall pattern, surrounded by a brown-and-white zigzag border that adds to the shimmering effect of the design. Although it uses the traditional serrated zigzag motif, its colors are more muted, mostly browns, pale orange, and white. The *Yei* are somewhat abstract, in the manner characteristic of the Lukachukai–Greasewood area.

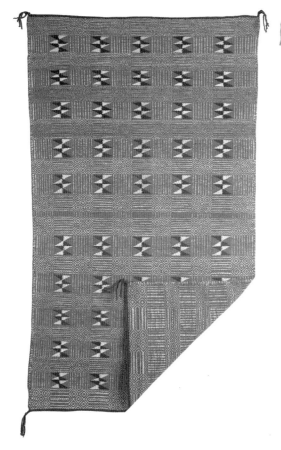

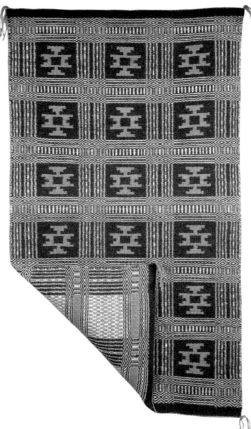

22

WEAVER	Daisy Redhorse
LOCALE	Crystal, New Mexico
DATE	ca. 1981
STYLE	Two-faced design
FUNCTION	Floor rug
MATERIAL	Hand-spun yarn
LENGTH	35½ inches
WIDTH	60½ inches
YARN COUNT	7 × 22

Although the repetitive zoned-band form is typically Crystal in style, the two-faced feature makes this an unusual and attractive textile.

23

WEAVER	Ruth Curley
LOCALE	Crystal, New Mexico
DATE	ca. 1981
STYLE	Two-faced design
FUNCTION	Floor rug
MATERIAL	Commercial yarn
LENGTH	50 inches
WIDTH	30 inches
YARN COUNT	4 × 26

The combined motifs and colors harmonize particularly well on this two-faced work, a remarkably well-woven textile. Bearing in mind that the weaver cannot see what she is creating on the opposite side as she works, one is even more profoundly impressed by the demonstration of her skill.

24

WEAVER	Mary Chee
LOCALE	Klagetoh, Arizona
DATE	ca. 1963
STYLE	Wide Ruins
FUNCTION	Floor rug
MATERIAL	Vegetal-dyed hand-spun yarn
LENGTH	88½ inches
WIDTH	62½ inches
YARN COUNT	12 × 42

The pastel tones of the plant dyes blend very smoothly in this fine rug's banded patterns (also often called "zoned weave," although zoning is a design form, not a weave). It is an excellent later example of the style created by Sallie and Bill Lippincott at Wide Ruins (Kinteel) in the 1940s.

25

WEAVER	Bessie George
LOCALE	Wide Ruins, Arizona
DATE	ca. 1980
STYLE	Wide Ruins
FUNCTION	Floor rug
MATERIAL	Vegetal-dyed hand-spun yarn
LENGTH	82 inches
WIDTH	59 inches
YARN COUNT	10 × 34

This is a fine vegetal-dyed textile with banded patterns in pastel shades of ocher and brown and the wavy-line treatment characteristic of recent Wide Ruins weaving.

26

WEAVER	Rita Yazzie
LOCALE	Wide Ruins, Arizona
DATE	ca. 1976
STYLE	Wide Ruins
FUNCTION	Floor rug
MATERIAL	Vegetal-dyed hand-spun yarn
LENGTH	120 inches
WIDTH	69 inches
YARN COUNT	11 × 42

This piece is woven in the typical Wide Ruins zoned treatment: three major bands of serrated diamond motifs separated by narrower bands. This is a perfect example of the more recent elaboration of the earlier zoned theme in well-balanced shades of brown and ocher, with white, grey, and black.

WEAVER	Betty Roan
LOCALE	Wide Ruins, Arizona
DATE	ca. 1982
STYLE	Wide Ruins
FUNCTION	Floor rug
MATERIAL	Vegetal-dyed hand-spun yarn
LENGTH	48½ inches
WIDTH	35½ inches
YARN COUNT	13 × 50

The division of the field into four major panels in strong brown, ocher, and white tones against a softer zoned background is somewhat unusual, but it works harmoniously to make this a fine example of the Wide Ruins style.

WEAVER	Katie Wauneka
LOCALE	Fort Defiance, Arizona
DATE	ca. 1981
STYLE	Pictorial
FUNCTION	Floor rug
MATERIAL	Commercial yarn
LENGTH	72 inches
WIDTH	50 inches
YARN COUNT	11 × 42

This well-woven rug features thirty brilliant yellow butterflies in six rows against a Crystal-style dark brown banded background. It is a very surprising design, in view of the Navajo belief that *kálugi* (butterfly) possesses evil magic and can cause witchcraft spells; it is also symbolic of a short life. It would undoubtedly never grace a Navajo home!

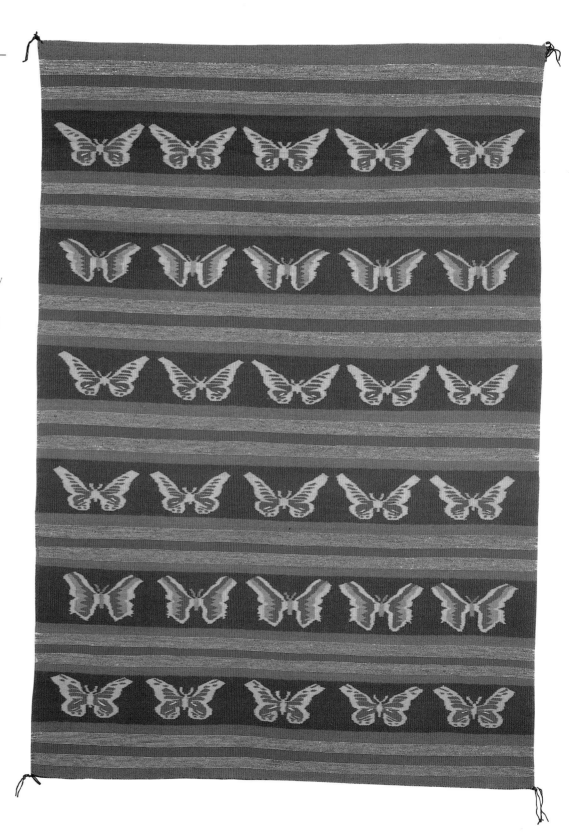

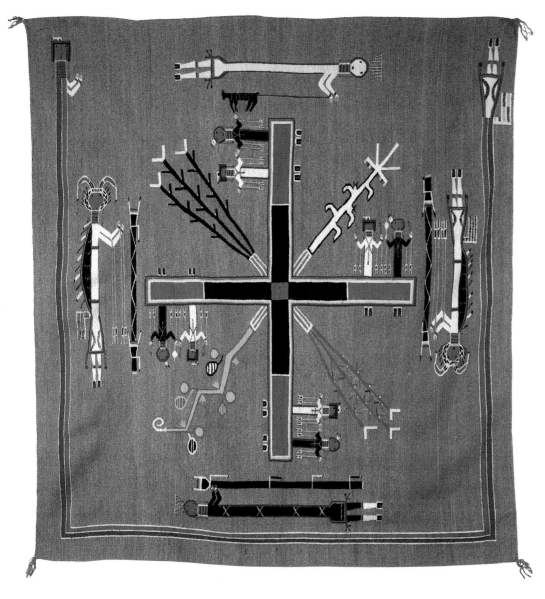

29

WEAVER	Mrs. Sam (Gladys) Manuelito
LOCALE	Newcomb, New Mexico
DATE	ca. 1945
STYLE	Sand Painting: Night Way
FUNCTION	Wall hanging
MATERIAL	Commercial yarn
LENGTH	67½ inches
WIDTH	62 inches
YARN COUNT	13 × 48

By one of the nieces of Hosteen Klah, this fine sand-painting textile depicts the raft of Whirling Logs, *Náhokos*, on which the Holy Twins were saved from drowning. The four larger figures represent Talking God, House God, and two Humpback Gods; on the logs are four pairs of male and female Holy People and four sacred plants. In the center is the Emergence Lake.

30

WEAVER	Mrs. Sam (Gladys) Manuelito
LOCALE	Newcomb, New Mexico
DATE	ca. 1945
STYLE	Sand Painting: Night Way
FUNCTION	Wall hanging
MATERIAL	Hand-spun yarn
LENGTH	67 inches
WIDTH	63 inches
YARN COUNT	10 × 46

Another fine sand-painting weave by one of the nieces of Hosteen Klah, this work is a tribute to his teaching as well as her skill. The design depicts Humpback Gods with their staffs, Fringe Mouth Gods, and four *Yeiba'ad*, surrounded by a Rainbow God. A sacred corn plant is in the center, growing out of an earth mound.

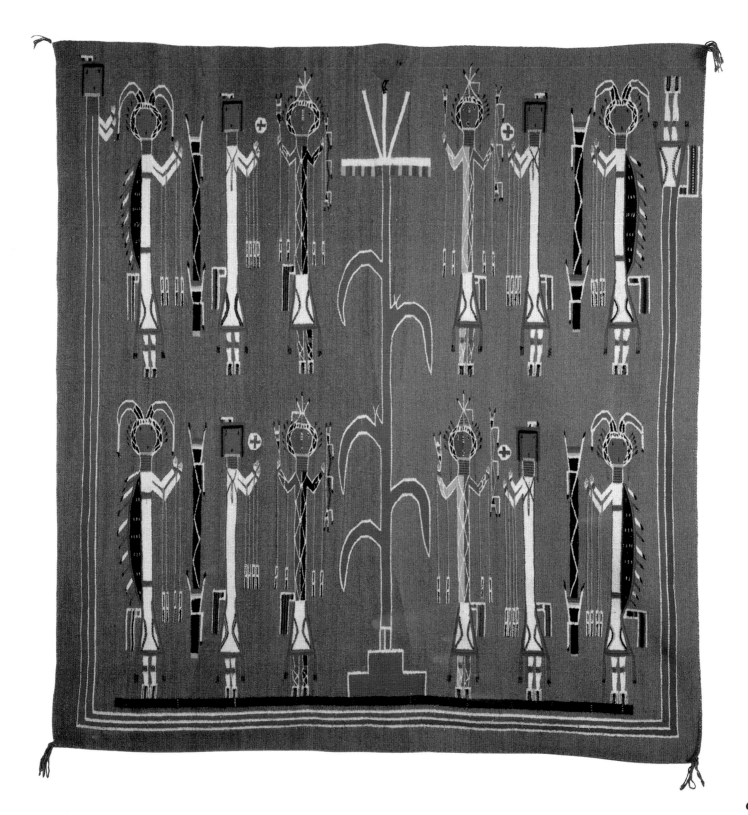

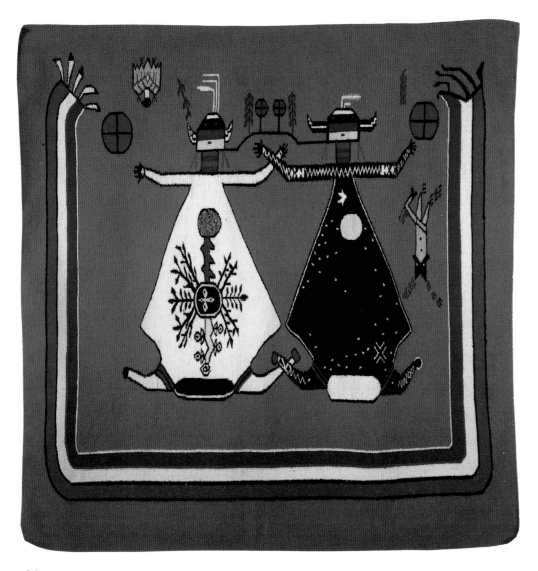

31

WEAVER	Despah Nez
LOCALE	Oak Springs, Arizona
DATE	ca. 1965
STYLE	Sand Painting: Mother Earth, Father Sky
FUNCTION	Wall hanging
MATERIAL	Commercial yarn
LENGTH	41½ inches
WIDTH	41½ inches
YARN COUNT	14 × 56

Two important mythological Beings, Mother Earth and Father Sky, are represented in this textile. Four sacred plants grow out of the Emergence Lake on her white body, and a bat flies above her head. His body, which is black, is decorated with the Sun and constellations, and a medicine pouch is at his side. Both have buffalo-horn headdresses and gourd rattles; they are united by a corn-pollen path. This design varies somewhat from the usual depiction of the theme.

32

WEAVER	Mrs. Big Joe
LOCALE	Farmington, New Mexico
DATE	ca. 1967
STYLE	Sand Painting: Beauty Way
FUNCTION	Wall hanging
MATERIAL	Commercial yarn
LENGTH	63½ inches
WIDTH	58½ inches
YARN COUNT	11 × 44

A superbly balanced design, with an unusual color scheme, this fine textile lives up to the name of the ceremony in which it is used. Four pairs of Holy People stand on Rainbows, holding rattles and sacred paraphernalia; in the center is a sacred corn plant growing out of the earth. At one side are eight weasel-skin medicine pouches; two *Dontso* Messenger Flies guard the Rainbow opening. Due to the compulsion among White observers to give names to Indian designs, this is known popularly as the "Navajo Tree of Life"—but not among the Navajo themselves.

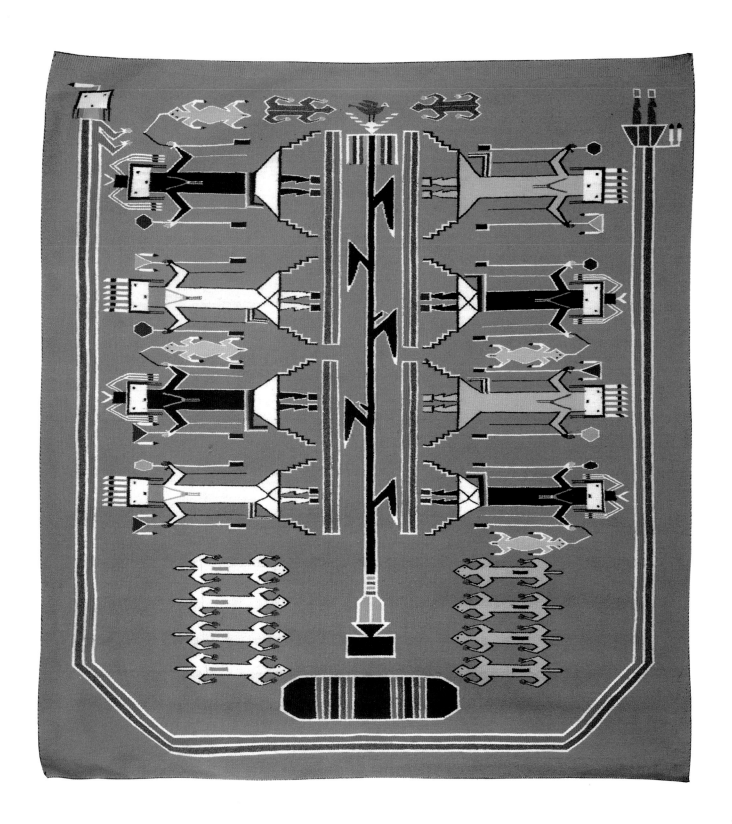

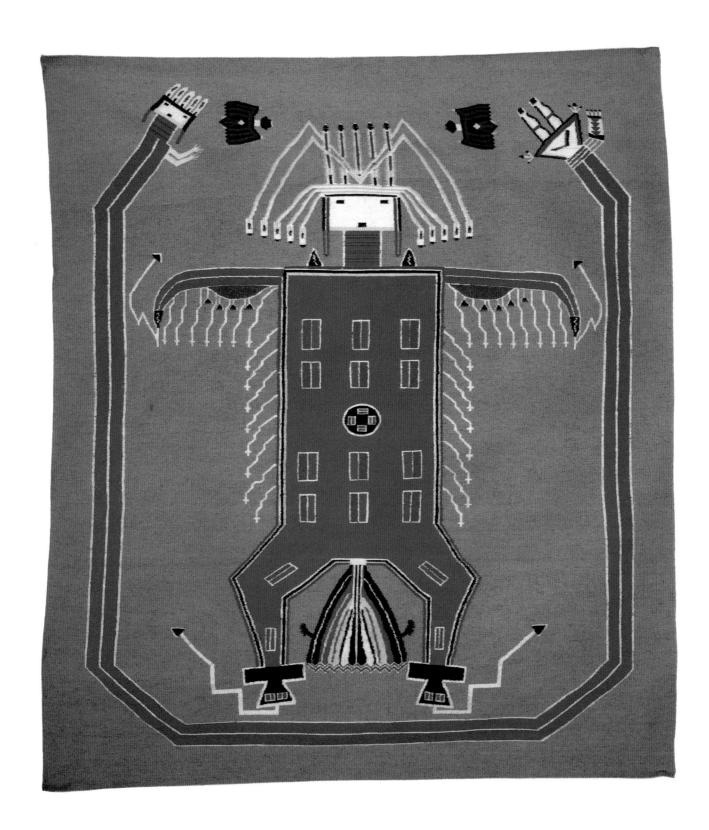

33

WEAVER	Despah Nez
LOCALE	Oak Springs, Arizona
DATE	ca. 1984
STYLE	Sand Painting: Big Thunder
FUNCTION	Wall hanging
MATERIAL	Hand-spun yarn
LENGTH	66 inches
WIDTH	57½ inches
YARN COUNT	15 × 60

This is a dramatic rendering of Big Thunder, an important ceremonial figure who occurs in several sand paintings. His body has Rainbow elements, lightning edges, a feathered tail, and cloud-symbol feet; he is protected by the ever-present Rainbow God and two bats flying overhead. He represents the essence of all thunderstorms, with their fearful power and unpredictability. He is "bigness" personified.

34

WEAVER	Anna Mae Tanner
LOCALE	Oak Springs, Arizona
DATE	ca. 1973
STYLE	Sand Painting: Great Star Chant
FUNCTION	Wall hanging
MATERIAL	Commercial yarn
LENGTH	65½ inches
WIDTH	53 inches
YARN COUNT	17 × 46

This very simple initiatory sand-painting design depicts the Star Trail leading the patient to the *hogán*. Each circle represents one of the Sacred Mountains over which he passes before entering to start the ceremony. The small paw designs represent the bears' footprints; guardian stars are within the red boundary. This design is for a man; a female patient would have differently colored bears.

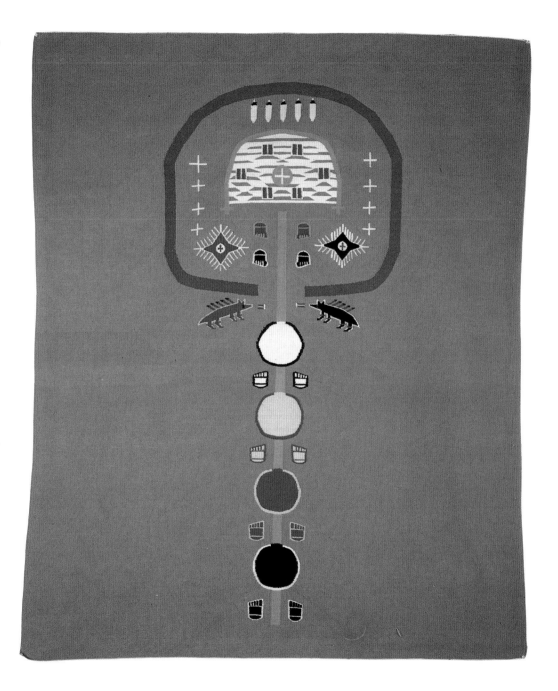

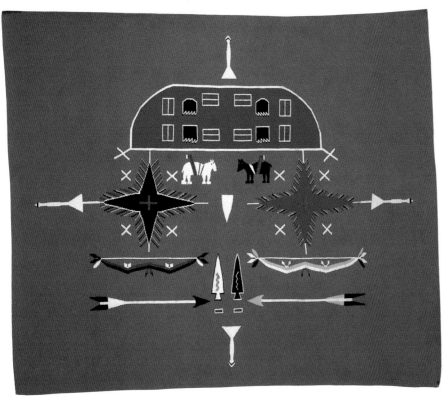

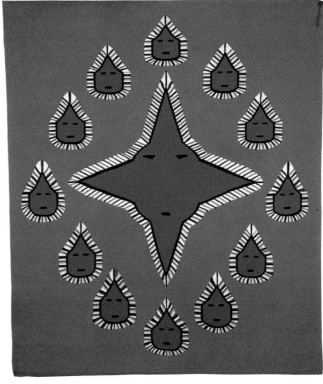

35

WEAVER	Alberta Thomas
LOCALE	Oak Springs, Arizona
DATE	ca. 1973
STYLE	Sand Painting: Great Star Chant
FUNCTION	Wall hanging
MATERIAL	Commercial yarn
LENGTH	61½ inches
WIDTH	52½ inches
YARN COUNT	14 × 66

A complicated design used in star gazing and removing evil, this shows the homes of the bears on Spruce Hill with their Rainbow guardians; the paws emphasize that this is their home. Near the male and female bears is a white, cone-shaped rock crystal, which is used in star gazing. At each side are the Main Stars with their fires in red; around them are other stars. Protective bows and arrows are to the west, with flint knives in between. At the four directions are White Dawn mountains with long prayer feathers.

36

WEAVER	Alberta Thomas
LOCALE	Oak Springs, Arizona
DATE	ca. 1974
STYLE	Sand Painting: Great Star Chant
FUNCTION	Wall hanging
MATERIAL	Commercial yarn
LENGTH	54½ inches
WIDTH	46½ inches
YARN COUNT	17 × 62

This depicts the Great Blue Star surrounded by twelve small evil stars, a very powerful evil-chasing ceremony held for a woman. Stars are dangerous because they cannot be seen in daylight and their movements cannot be traced at night. That is why people have sickness and accidents at night.

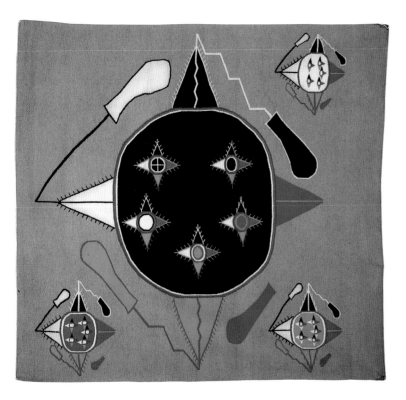

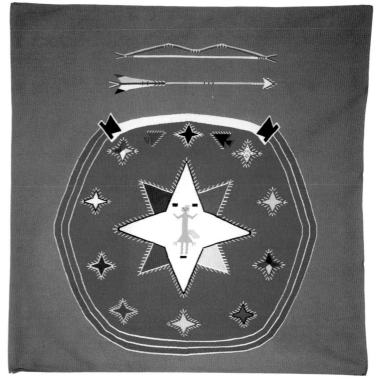

37

WEAVER	Anna Mae Tanner
LOCALE	Oak Springs, Arizona
DATE	ca. 1975
STYLE	Sand Painting: Great Star Chant
FUNCTION	Wall hanging
MATERIAL	Commercial yarn
LENGTH	61½ inches
WIDTH	59½ inches
YARN COUNT	14 × 62

Representing an evil-chasing rite, this is the Great Black Star form. The circle represents the black sky *hogán*, with five Great Star People inside. Ceremonial flint knives are tied to the four points by lines. The three smaller stars are all variants of the central design, used on subsequent days of the four-day ceremony; they differ only in color.

38

WEAVER	Anna Mae Tanner
LOCALE	Oak Springs, Arizona
DATE	ca. 1974
STYLE	Sand Painting: Great Star Chant
FUNCTION	Wall hanging
MATERIAL	Commercial yarn
LENGTH	59 inches
WIDTH	58½ inches
YARN COUNT	14 × 52

This is a beautiful design from the Little Star Chant portion of the Great Star rite. In the center is Yellow Pollen Boy, standing on the White Star of dawn, surrounded by ten other stars, on a blue field, all contained within a Rainbow and guarded at the opening by magical points made of flint or black obsidian. The Rainbow ends in cloud-and-rain symbols. The white line is the light of dawn, protected by a bow and arrow.

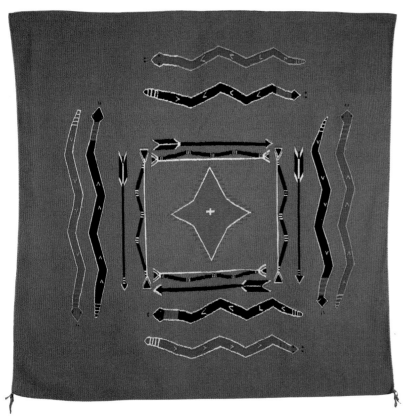

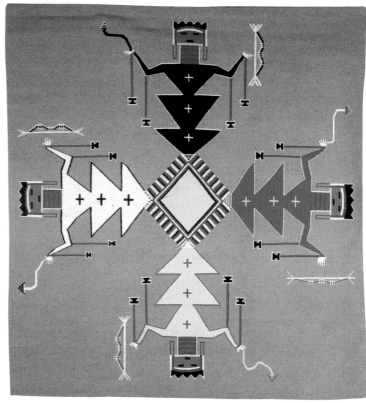

39

WEAVER	Despah Nez
LOCALE	Oak Springs, Arizona
DATE	ca. 1963
STYLE	Sand Painting: Great Star Chant
FUNCTION	Wall hanging
MATERIAL	Commercial yarn
LENGTH	51 inches
WIDTH	52½ inches
YARN COUNT	15 × 46

Used to chase evil from the patient, this has a Great Red Star in the center, flanked by four bow-and-arrow sets. Four Black Snakes protect the arrows, while Blue Snakes guard the sand painting itself.

40

WEAVER	Alberta Thomas
LOCALE	Oak Springs, Arizona
DATE	ca. 1975
STYLE	Sand Painting: Great Star Chant
FUNCTION	Wall hanging
MATERIAL	Commercial yarn
LENGTH	60 inches
WIDTH	56 inches
YARN COUNT	15 × 58

The Little Star section of the Great Star Chant, this shows the Yellow Star in the center, giving off light rays. Female Cloud People wearing brown leather wind masks are standing at the points of the star. Each of them holds a bow and a flint arrow point; rain bundles hang from each arm. Their bodies are in triangular segment form and are decorated with stars.

41

WEAVER	Despah Nez
LOCALE	Oak Springs, Arizona
DATE	ca. 1972
STYLE	Sand Painting: Great Star Chant
FUNCTION	Wall hanging
MATERIAL	Commercial yarn
LENGTH	53 inches
WIDTH	53 inches
YARN COUNT	17 × 54

Directional Holy Rain People, dressed in flint armor, stand on the Little Star. Each wears a brown leather wind mask, has cloud-and-rain symbols suspended from his arms, and carries a bow and arrows.

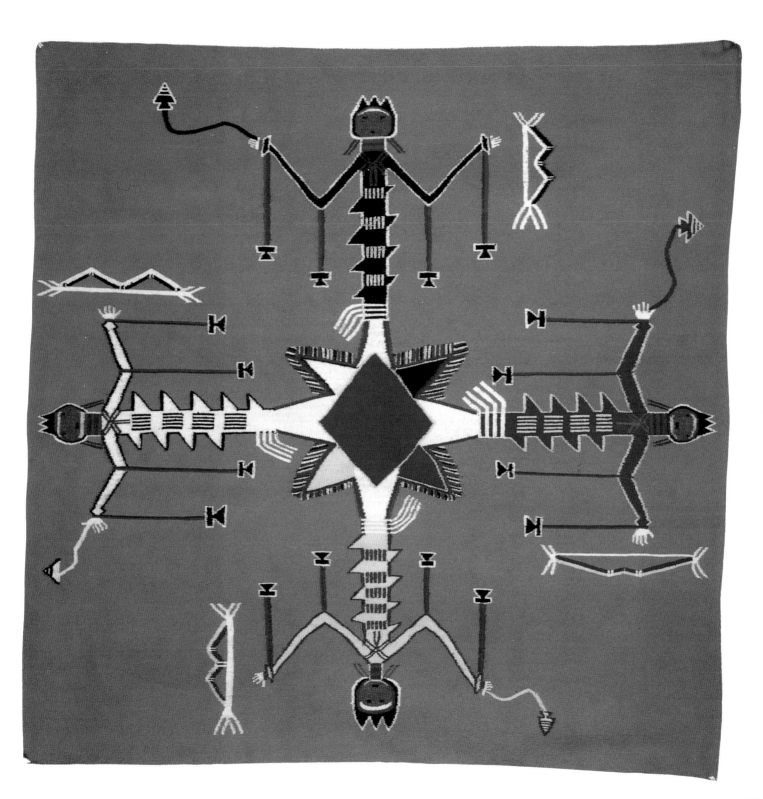

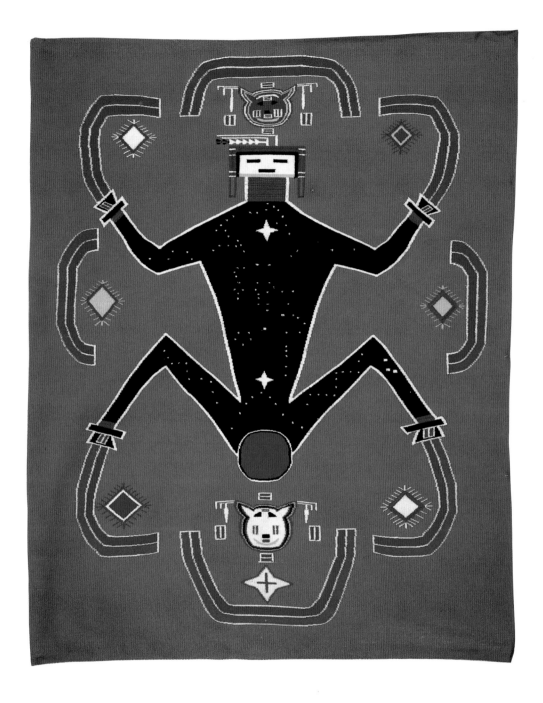

42

WEAVER	Alberta Thomas
LOCALE	Oak Springs, Arizona
DATE	ca. 1972
STYLE	Sand Painting: Great Star Chant
FUNCTION	Wall hanging
MATERIAL	Commercial yarn
LENGTH	61 inches
WIDTH	48½ inches
YARN COUNT	15 × 60

Father Sky, wearing a white mask, is decorated with a thinly defined Milky Way, constellations, and the Twin Stars. He is seated on blue daylight and carries cloud-and-rain symbols in his hands. Above his head is the Sun with a Coyote Star; the Moon and a Coyote Star are to the west. Stars and protecting Rainbows surround the design.

43

WEAVER	Despah Nez
LOCALE	Oak Springs, Arizona
DATE	1970
STYLE	Sand Painting: Great Star Chant
FUNCTION	Wall hanging
MATERIAL	Commercial yarn
LENGTH	54½ inches
WIDTH	53 inches
YARN COUNT	15 × 60

This complicated and especially powerful design is used to heal wounds. Four Star People wearing brown leather wind masks and dressed in flint armor stand on the central Black Star, which emits fire and arrowheads. Each is armed with flint knives, arrows, and a war shield and is accompanied by a star and a Snake Protector. The Rainbow God wears a mask and armor, and Rainbow spots guard the opening. Four pairs of *Dontsos* also guard the Star People.

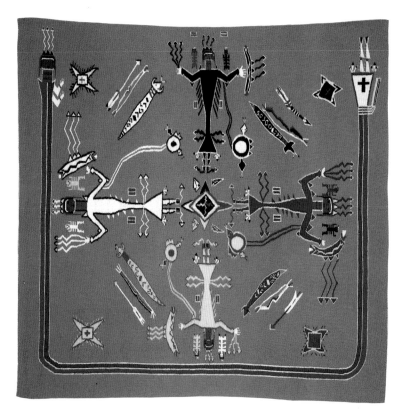

44

WEAVER	Anna Mae Tanner
LOCALE	Oak Springs, Arizona
DATE	ca. 1967
STYLE	Sand Painting: Great Star Chant
FUNCTION	Wall hanging
MATERIAL	Commercial yarn
LENGTH	55½ inches
WIDTH	56 inches
YARN COUNT	19 × 58

Seated on the central Great Blue Star are four Star People, holding rattles and cloud symbols, guarded by four pairs of *Dontsos*. Above the head of each of the Star People are a star and a directional band representing the Sacred Mountains of the Navajo; between these are Rainbows represented by short bars. Four holy plants grow out of the center, which has a circular *hogán* with a cross-stick star fire.

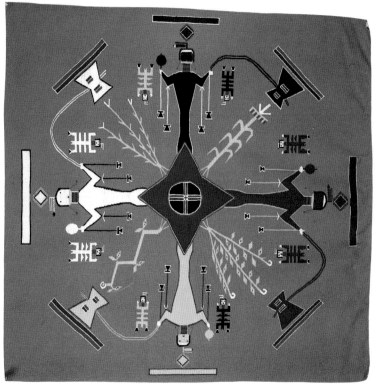

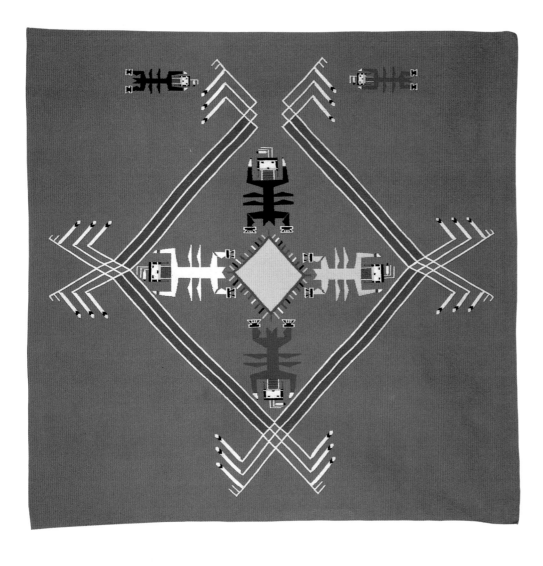

45

WEAVER	Alberta Thomas
LOCALE	Oak Springs, Arizona
DATE	ca. 1974
STYLE	Sand Painting: Great Star Chant
FUNCTION	Wall hanging
MATERIAL	Commercial yarn
LENGTH	64½ inches
WIDTH	62½ inches
YARN COUNT	15 × 58

This design represents a blessing ceremony, with the Great Yellow Star in the center, protected by four large *Dontso* messengers. Feathered Rainbows surround the outside, with the opening guarded by two smaller *Dontsos*.

46

WEAVER	Anna Mae Tanner
LOCALE	Oak Springs, Arizona
DATE	ca. 1973
STYLE	Sand Painting: Great Star Chant
FUNCTION	Wall hanging
MATERIAL	Commercial yarn
LENGTH	62½ inches
WIDTH	58 inches
YARN COUNT	16 × 60

Representing a blessing ceremony, this brilliant hooked-diamond design has two Star Warriors in the center, with their bows and arrows and five great stars. They carry gourd rattles and lightning arrows in their hands. Each banded Rainbow opening has prayer feathers and is guarded by a *Dontso*.

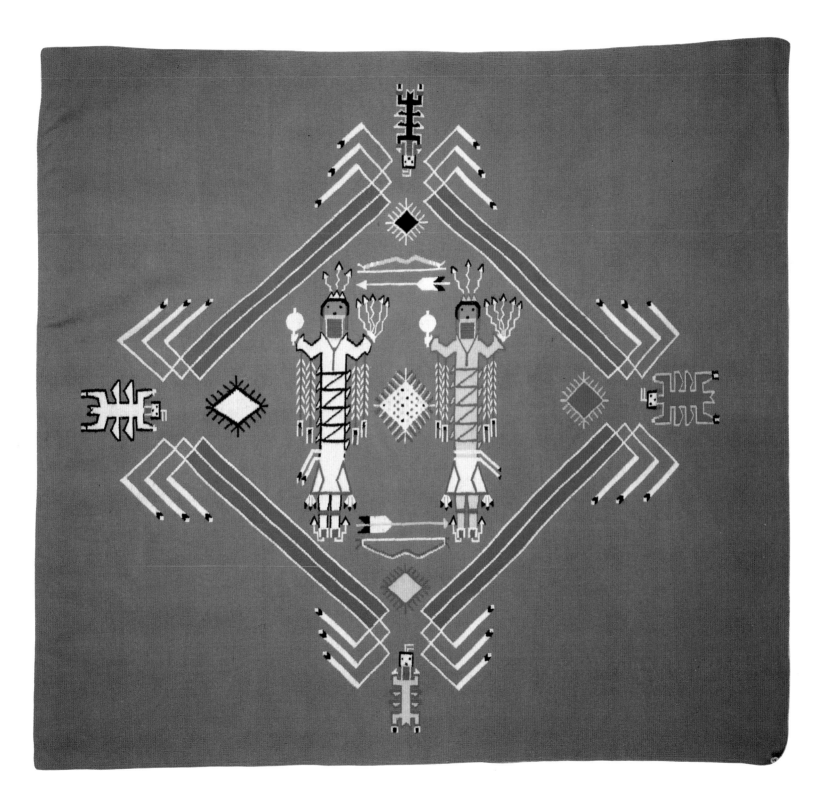

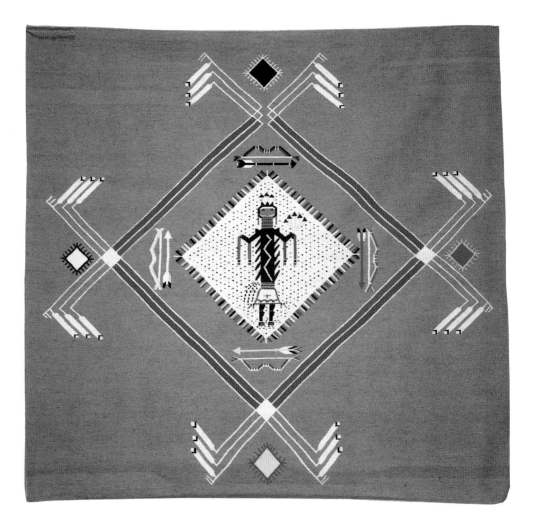

47

WEAVER	Alberta Thomas
LOCALE	Oak Springs, Arizona
DATE	ca. 1982
STYLE	Sand Painting: Great Star Chant
FUNCTION	Wall hanging
MATERIAL	Commercial yarn
LENGTH	64½ inches
WIDTH	61½ inches
YARN COUNT	13 × 62

Representing a blessing ceremony, this design portrays *Nayénezgani*, the Monster Slayer, standing in the center of the multicolored Great Star. Bows and arrows protect him within the feathered Rainbow diamond, and there is a directional star at each of the four corners.

48

WEAVER	Vera Begay
LOCALE	Oak Springs, Arizona
DATE	ca. 1950–66
STYLE	Sand Painting: Red Ant Way
FUNCTION	Wall hanging
MATERIAL	Commercial yarn
LENGTH	63 inches
WIDTH	63 inches
YARN COUNT	15 × 60

The difficult technique of weaving curved lines is shown in this sand-painting textile depicting deer, antelope, birds, and four sacred plants growing out of the Emergence Lake center. The four trails lead to the homes of the Red Ant People. Two *Dontsos* guard the opening.

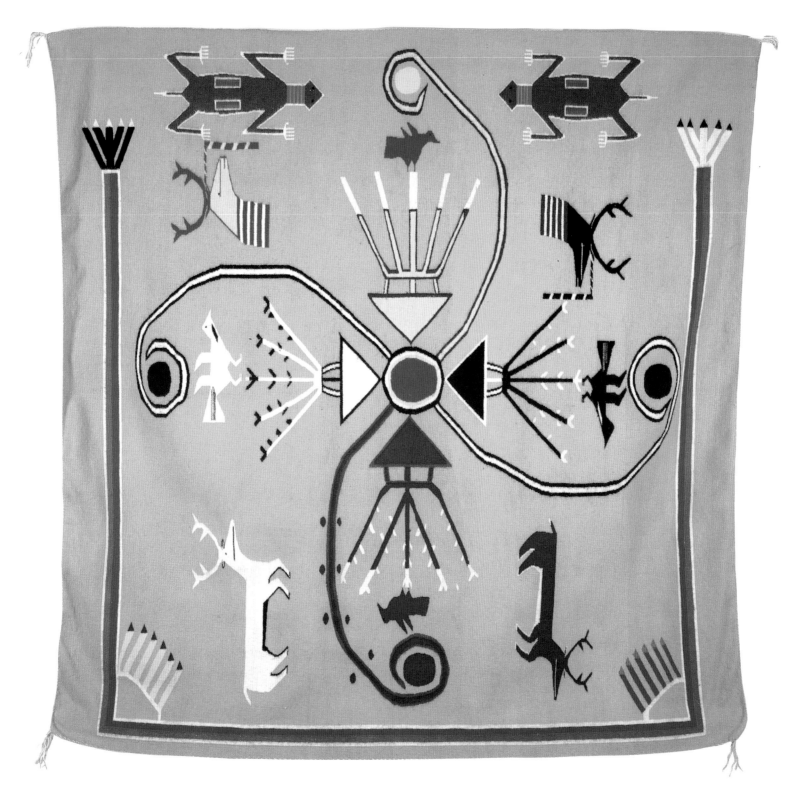

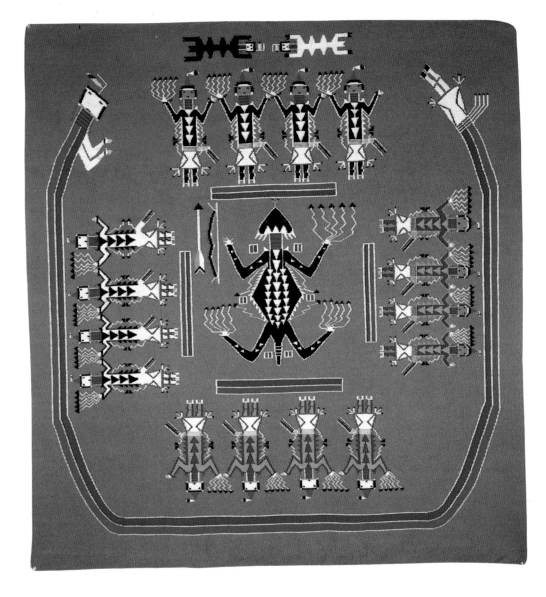

WEAVER	Alberta Thomas
LOCALE	Oak Springs, Arizona
DATE	ca. 1968
STYLE	Sand Painting: Red Ant Way
FUNCTION	Wall hanging
MATERIAL	Commercial yarn
LENGTH	53½ inches
WIDTH	57½ inches
YARN COUNT	15 × 66

At the center of this design is the Great Horned Toad, surrounded by four groups of Horned Toad people. The Rainbow opening is guarded by two *Dontsos*; the hands of the Rainbow God are extended to receive an offering bowl.

50

WEAVER	Grace Joe
LOCALE	Red Valley, Arizona
DATE	ca. 1969
STYLE	Sand Painting: Red Ant Way
FUNCTION	Wall hanging
MATERIAL	Commercial yarn
LENGTH	49 inches
WIDTH	52 inches
YARN COUNT	13 × 56

This very well-balanced design portrays the Horned Toads from the four directions, each in flint armor, with bows and arrows, and surrounded by their lightning protection. In the center is the home of the Red Ant People.

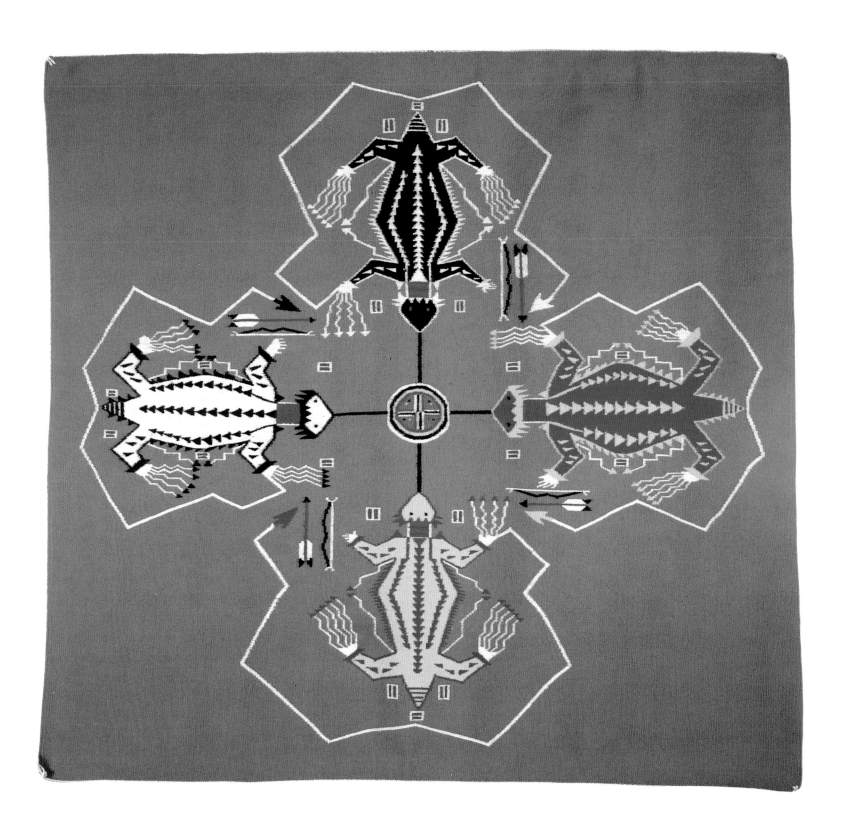

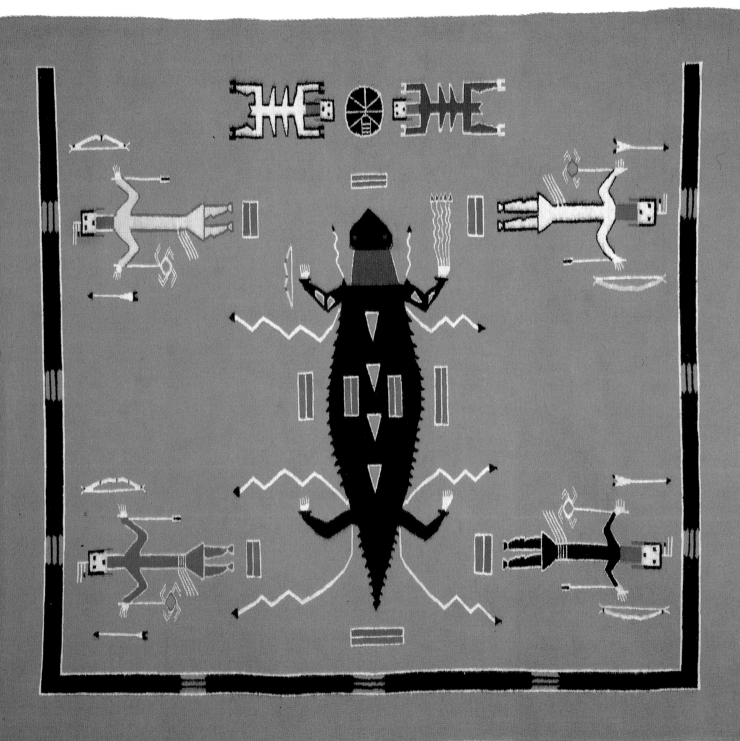

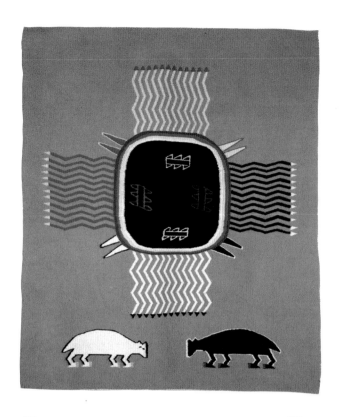

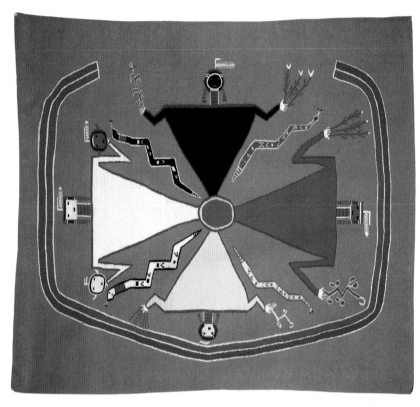

51

WEAVER	Grace Joe
LOCALE	Red Valley, Arizona
DATE	ca. 1973
STYLE	Sand Painting: Red Ant Way
FUNCTION	Wall hanging
MATERIAL	Commercial yarn
LENGTH	56 inches
WIDTH	50½ inches
YARN COUNT	15 × 42

This fine square design has the Great Horned Toad in the center, and four Red Ant People. The Great Horned Toad exudes power lightning, is armed with a bow and arrows, and is protected by Rainbows. The black band represents his dangerous power; two *Dontsos* guard the opening, with a *hogán* or Emergence Place between.

52

WEAVER	Grace Joe
LOCALE	Red Valley, Arizona
DATE	ca. 1973
STYLE	Sand Painting: Red Ant Way
FUNCTION	Wall hanging
MATERIAL	Commercial yarn
LENGTH	45½ inches
WIDTH	38½ inches
YARN COUNT	14 × 50

This beautifully symmetrical design has the Emergence Lake (in black) as a central motif, radiating lightning to the four directions; the two bears are guardians.

53

WEAVER	Despah Nez
LOCALE	Oak Springs, Arizona
DATE	ca. 1972
STYLE	Sand Painting: Coyote Way
FUNCTION	Wall hanging
MATERIAL	Commercial yarn
LENGTH	60 inches
WIDTH	54½ inches
YARN COUNT	17 × 62

This design represents a sand painting from the Coyote Way ceremony, a ritual that is seen infrequently and has almost disappeared today. A bold Maltese Cross pattern is used here to represent the four holy periods of the day. Each personage holds sacred plants in his hands; the East is shown by the Sun and Moon, held in the hands of the Eastern God. Four zigzag racer snakes issue from the blue water center. The full circular effect of this design has been slightly constricted by the weaver.

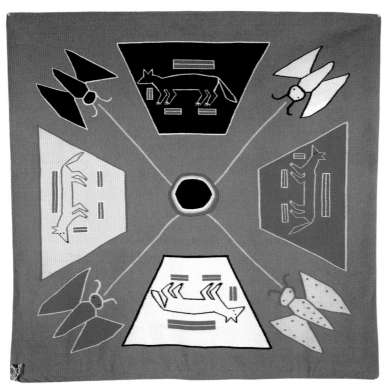
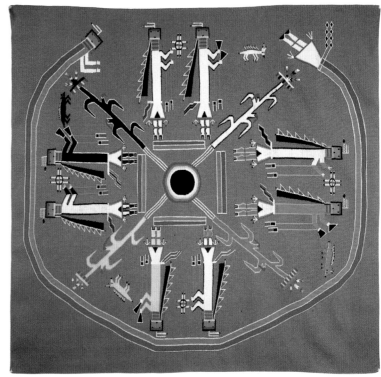

54

WEAVER	Anna Mae Tanner
LOCALE	Oak Springs, Arizona
DATE	ca. 1970
STYLE	Sand Painting: Coyote Way
FUNCTION	Wall hanging
MATERIAL	Commercial yarn
LENGTH	61½ inches
WIDTH	59½ inches
YARN COUNT	15 × 60

Another of the rarely seen designs from the Coyote Way ceremony, this textile features the four-direction motifs. The four trapezoid sections represent the homes of the Coyotes, who are calling for rain; butterflies follow pollen paths to the water circle in the center.

55

WEAVER	Anna Mae Tanner
LOCALE	Oak Springs, Arizona
DATE	ca. 1968
STYLE	Sand Painting: Coyote Way
FUNCTION	Wall hanging
MATERIAL	Commercial yarn
LENGTH	65½ inches
WIDTH	63 inches
YARN COUNT	15 × 56

Eight Coyote maidens stand on earth bars, holding ceremonial baskets and rawhide rattles. Four corn plants grow out of the water circle, guarded by four feather-decorated foxes. The overall form is less well-balanced than no. 56; it suggests that the weaver ran into difficulty in her designing of this textile.

56

WEAVER	Anna Mae Tanner
LOCALE	Oak Springs, Arizona
DATE	ca. 1970
STYLE	Sand Painting: Coyote Way
FUNCTION	Wall hanging
MATERIAL	Commercial yarn
LENGTH	65½ inches
WIDTH	61 inches
YARN COUNT	16 × 62

Similar to no. 55, this is a more fully realized and elaborated work by the same weaver, and also includes feathered foxes, baskets, and Coyote guardians. Although the iconography is much the same, it demonstrates how one person will vary the same subject from textile to textile. This design is also better balanced in overall form.

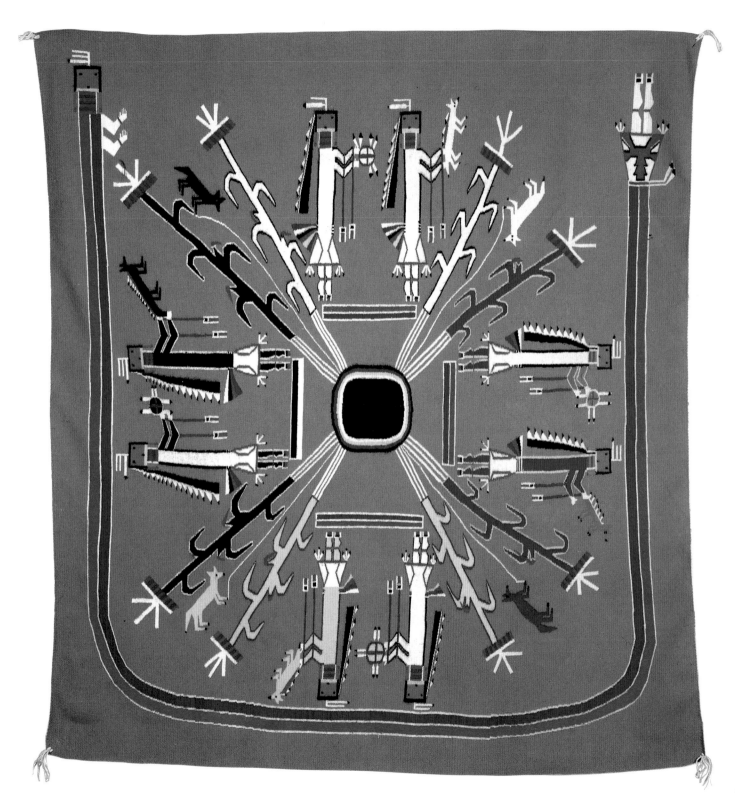

83

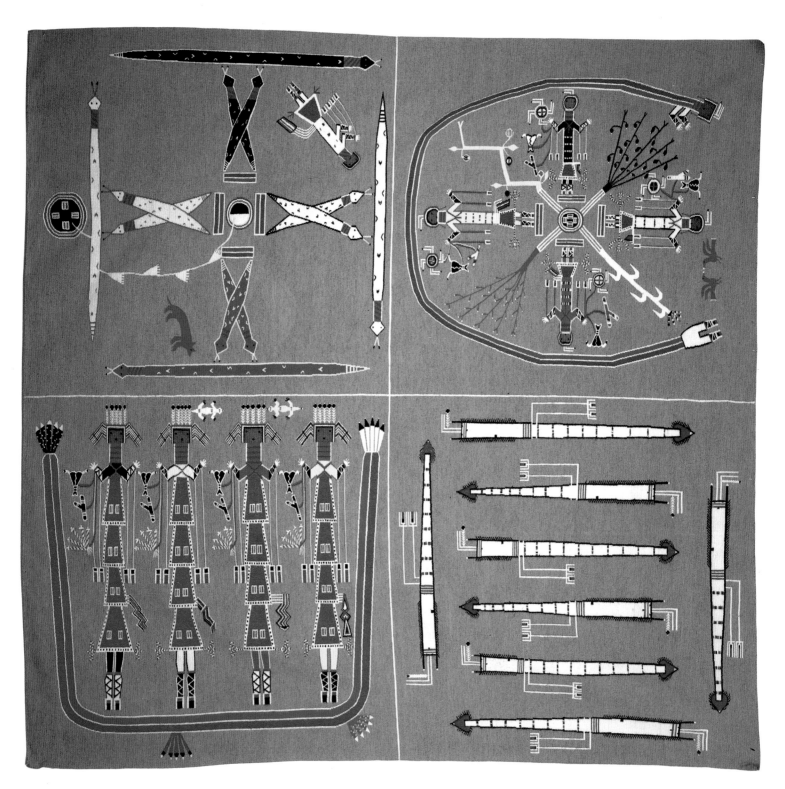

57

WEAVER	Anna Mae Tanner
LOCALE	Oak Springs, Arizona
DATE	ca. 1982
STYLE	Four-in-one: Mountain Chant
FUNCTION	Wall hanging
MATERIAL	Commercial yarn
LENGTH	98 inches
WIDTH	97 inches
YARN COUNT	12 × 58

Four rugs in one, this is composed of different sand-painting designs employed in the Mountain Chant. As sand paintings, these would normally be made individually and used over a four-day period, whereas they are combined here in a single textile.

58

WEAVER	Marie W. Begay
LOCALE	Kinlichee, Arizona
DATE	ca. 1972
STYLE	Raised Outline
FUNCTION	Floor rug
MATERIAL	Hand-spun yarn
LENGTH	58½ inches
WIDTH	37½ inches
YARN COUNT	11 × 50

This is an excellent example of the recent technique known as Raised Outline, developed in the Coal Mine Mesa region. The design is a sharply defined classic Storm Pattern in only two colors—brown and tan—with the *hogán* center, the four Sacred Mountains with lightning, and water bugs. (*See nos. 59 and 60 for comparable Raised Outline style; no. 61 for Storm Pattern.*)

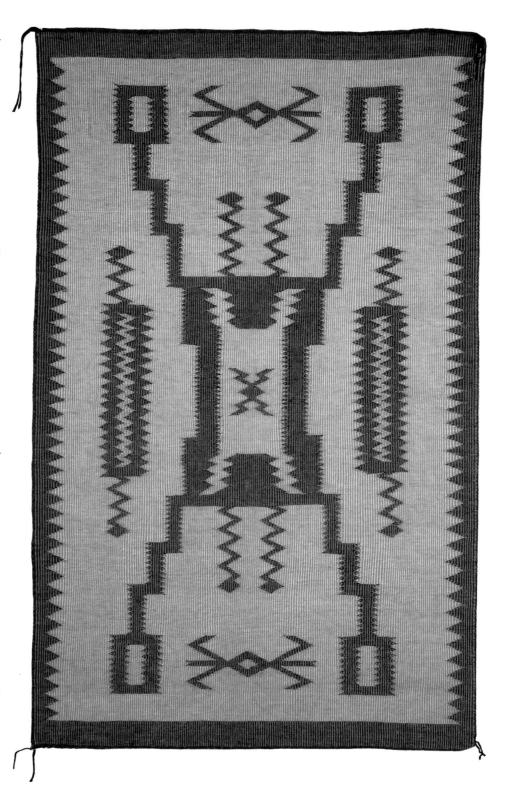

59

WEAVER	Mary Smith
LOCALE	Coal Mine Mesa, Arizona
DATE	ca. 1975
STYLE	Raised Outline
FUNCTION	Floor rug
MATERIAL	Hand-spun yarn
LENGTH	60 inches
WIDTH	35½ inches
YARN COUNT	10 × 34

Careful design, simple color combinations, and perfect weaving technique result in this beautifully balanced example of the Raised Outline style, although the bold zigzag diamond pattern is more reminiscent of the Four Corners region.

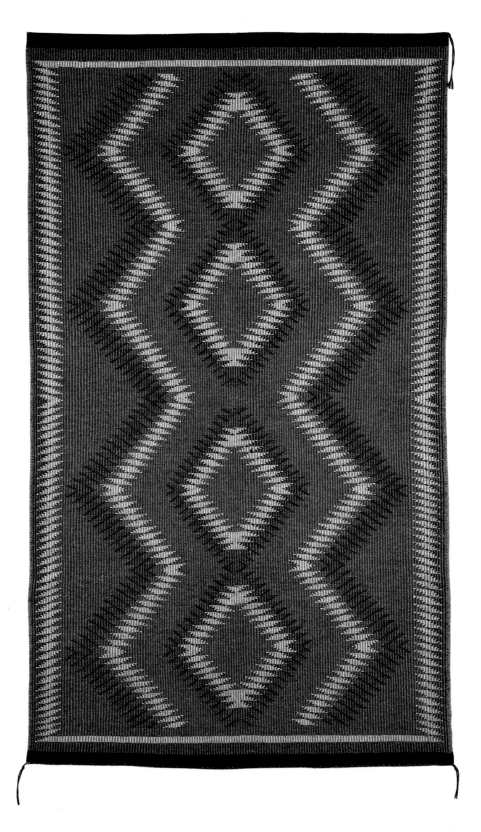

60

WEAVER	Cecelia Joe
LOCALE	Coal Mine Mesa, Arizona
DATE	ca. 1981
STYLE	Raised Outline
FUNCTION	Floor rug
MATERIAL	Vegetal-dyed hand-spun yarn
LENGTH	56½ inches
WIDTH	30 inches
YARN COUNT	10 × 40

With its strong plum-red color against a light grey-white background in the narrow form characteristic of these weaves, this is a perfect example of the typical Raised Outline style.

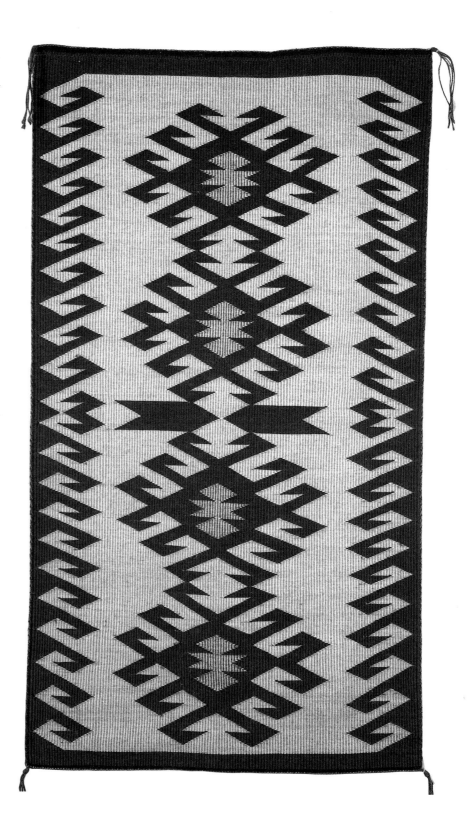

61

WEAVER	Rose Dan
LOCALE	Ganado, Arizona
DATE	ca. 1977
STYLE	Storm Pattern
FUNCTION	Floor rug
MATERIAL	Commercial yarn
LENGTH	36½ inches
WIDTH	62½ inches
YARN COUNT	8 × 36

In this unusual rectangular adaptation of the Storm Pattern, the central *hogán* motif and the lightning lines are squared off, and the four Sacred Mountains include repeated motifs. The two water bugs at the end are clearly recognizable but are larger in proportion to the whole design than is customarily seen with this pattern.

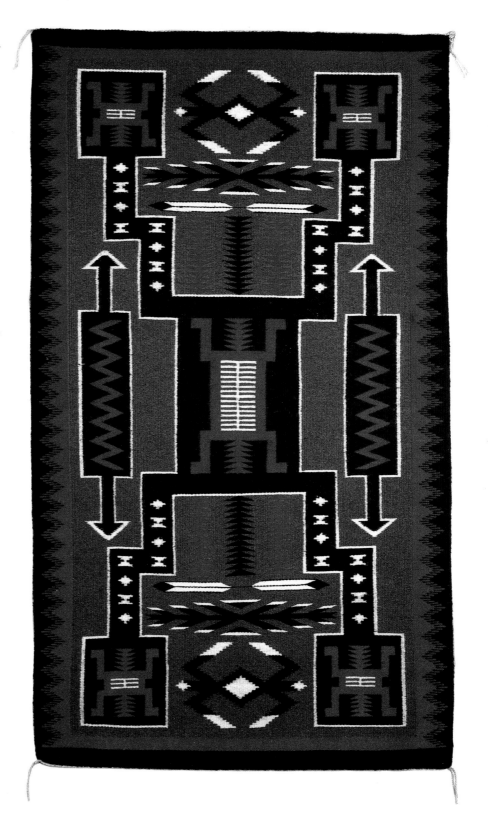

62

WEAVER	Angie Maloney
LOCALE	Tuba City, Arizona
DATE	ca. 1985
STYLE	Storm Pattern
FUNCTION	Wall hanging
MATERIAL	Hand-spun yarn
LENGTH	64½ inches
WIDTH	52 inches
YARN COUNT	17 × 66

This tightly woven example is divided into nine rectangular areas; the relationship of each to historical Navajo weaving is clearly evident. It is a somewhat abstract blend of pseudo-Oriental and Storm Pattern styles. A further interesting element is the line of feather motifs on each longitudinal border.

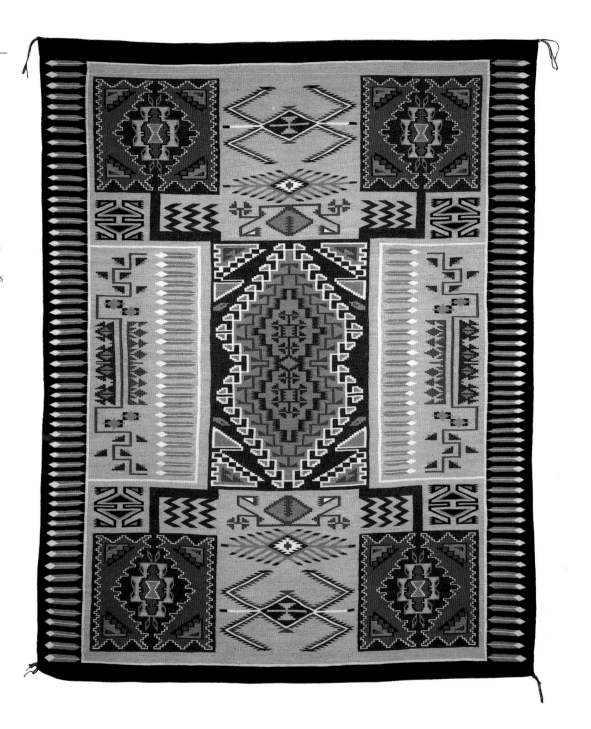

63

WEAVER	Stella Todacheeny
LOCALE	Greasewood, Arizona
DATE	ca. 1962
STYLE	Klagetoh
FUNCTION	Floor rug
MATERIAL	Commercial-dyed hand-spun yarn
LENGTH	117½ inches
WIDTH	83½ inches
YARN COUNT	10 × 32

The complexity of this design suggests the inspiration of Moore rather than of Hubbell, particularly the small corner motifs. However, the rug was woven about 1962; it is a very fine example of the kind of work done today in the region around Ganado and Klagetoh. The strong black, white, and Ganado red motifs on a grey background are characteristic of the Klagetoh design style.

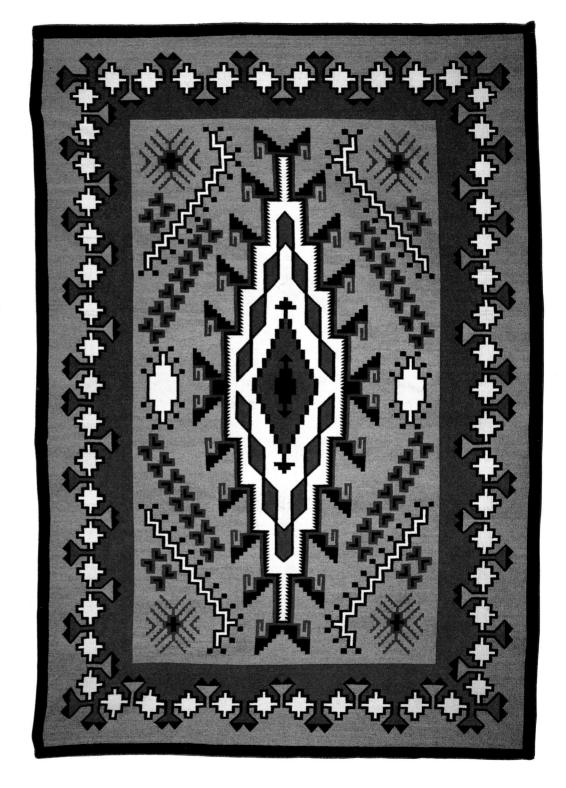

64

WEAVER	Betty Joe Yazzie
LOCALE	Klagetoh, Arizona
DATE	ca. 1983
STYLE	Klagetoh
FUNCTION	Floor rug
MATERIAL	Hand-spun yarn
LENGTH	92 inches
WIDTH	65½ inches
YARN COUNT	13 × 64

This fine, beautifully woven example of contemporary weaving employs the well-known Ganado red but incorporates it into the more elaborate Klagetoh design style.

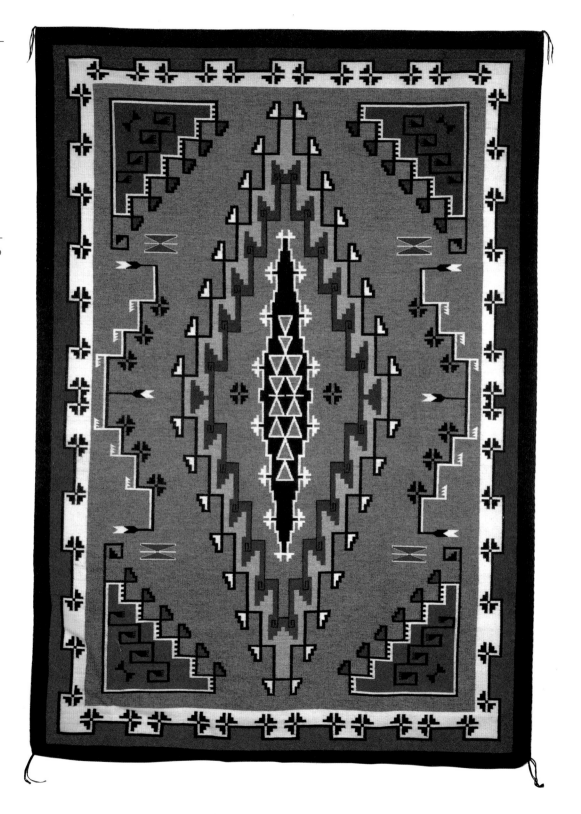

65

WEAVER	Stella Todacheeny
LOCALE	Greasewood, Arizona
DATE	ca. 1977
STYLE	Klagetoh
FUNCTION	Floor rug
MATERIAL	Hand-spun yarn
LENGTH	83½ inches
WIDTH	60 inches
YARN COUNT	11 × 62

An exuberant design somewhat similar in color and motif to those influenced by Hubbell and Moore, this textile presents an elaborate border with a complex central diamond.

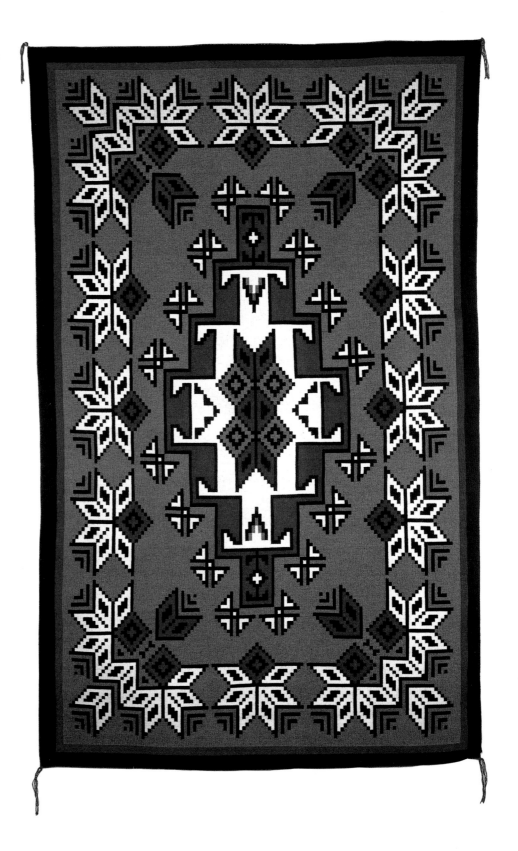

66

WEAVER	Unknown
LOCALE	Tees Nos Pos, Arizona
DATE	ca. 1900–1920
STYLE	Tees Nos Pos
FUNCTION	Floor rug
MATERIAL	Germantown yarn
LENGTH	129½ inches
WIDTH	77 inches
YARN COUNT	12 × 34

Although early for the region, the elaborate Tees Nos Pos style of busy border designs, interior framing, and complex central composition is evident in this large masterpiece, which reflects the frequent comment that these are "rugs within rugs."

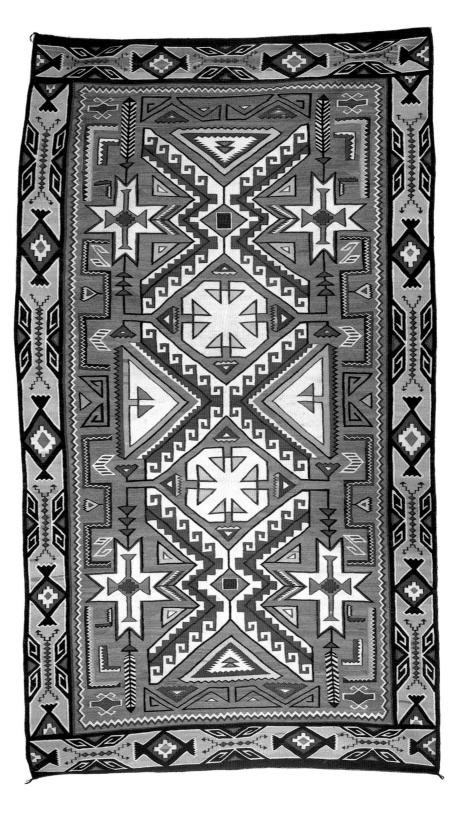

67

WEAVER	Roselyn Begay
LOCALE	Tees Nos Pos, Arizona
DATE	ca. 1980
STYLE	Tees Nos Pos
FUNCTION	Floor rug
MATERIAL	Vegetal-dyed yarn
LENGTH	85½ inches
WIDTH	66 inches
YARN COUNT	10 × 28

A typical complex Tees Nos Pos pattern, this shows the Two Grey Hills influence, but with design innovations by the weaver that make it almost two rugs in one. These are usually made from commercially dyed yarns.

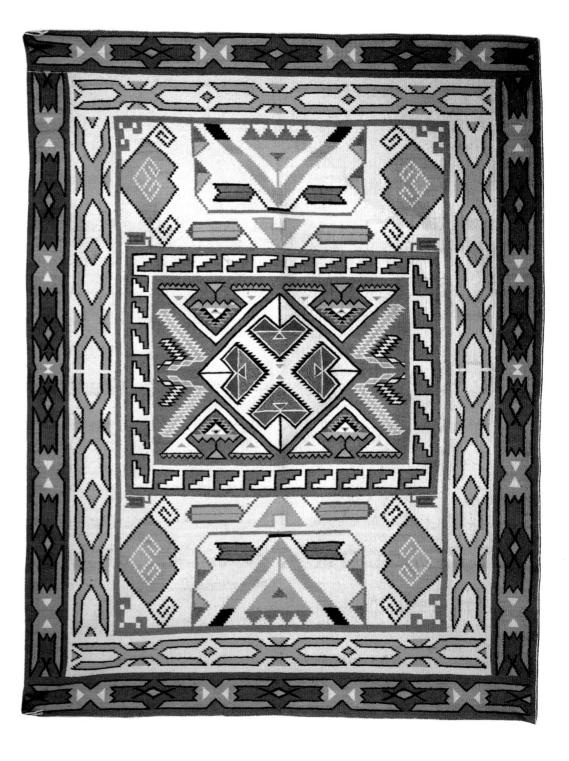

68

WEAVER	Unknown
LOCALE	Tees Nos Pos, Arizona
DATE	ca. 1910–20
STYLE	Tees Nos Pos
FUNCTION	Floor rug
MATERIAL	Commercial yarn
LENGTH	99½ inches
WIDTH	61½ inches
YARN COUNT	11 × 38

A typical Tees Nos Pos border design, with the Saltillo-derived Eye Dazzler center from the turn-of-the-century period, this has fewer colors than most. It is an early example of what has become a very popular style, although contemporary designs are far more complex and include more brilliant colors.

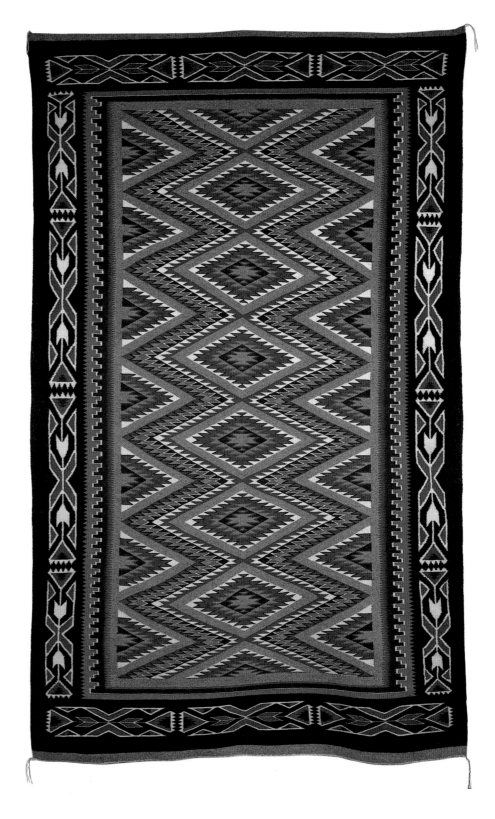

69

WEAVER	Maggie Price
LOCALE	Sanders, Arizona
DATE	ca. 1982
STYLE	Burntwater
FUNCTION	Floor rug
MATERIAL	Vegetal-dyed hand-spun yarn
LENGTH	97½ inches
WIDTH	58 inches
YARN COUNT	8 × 48

At first glance somewhat busy in appearance, this superior example, with its color scheme of terra cotta, soft browns, muted ocher, and contrasting touches of white, dramatically illustrates the elaborate decorative qualities of the Burntwater style.

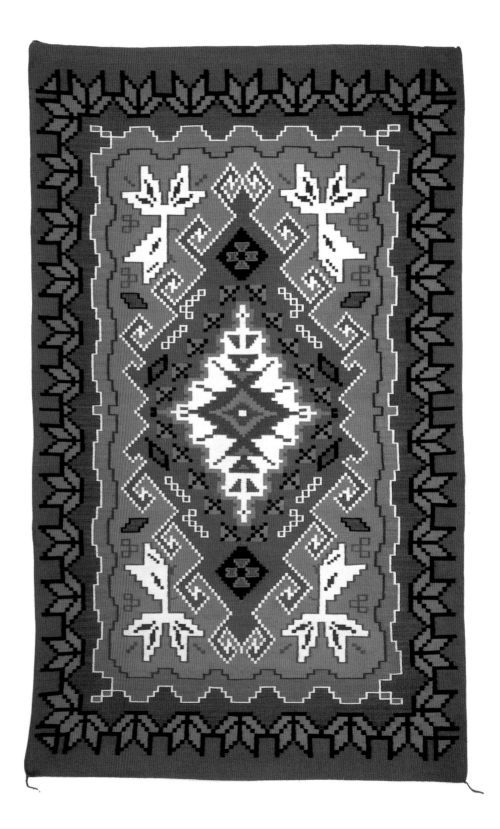

70

WEAVER	Philomena Yazzie
LOCALE	Sanders, Arizona
DATE	ca. 1979
STYLE	Burntwater
FUNCTION	Floor rug
MATERIAL	Commercial yarn
LENGTH	73 inches
WIDTH	47 inches
YARN COUNT	11 × 46

This splendid rug, by one of the finest weavers of
the area around Burntwater, Arizona, shows the
characteristic central serrated diamond and com-
plex border designs of textiles from that region.
The result is a singularly pleasing textile, with
the vibrancy that has made Navajo weaving
attractive to many people.

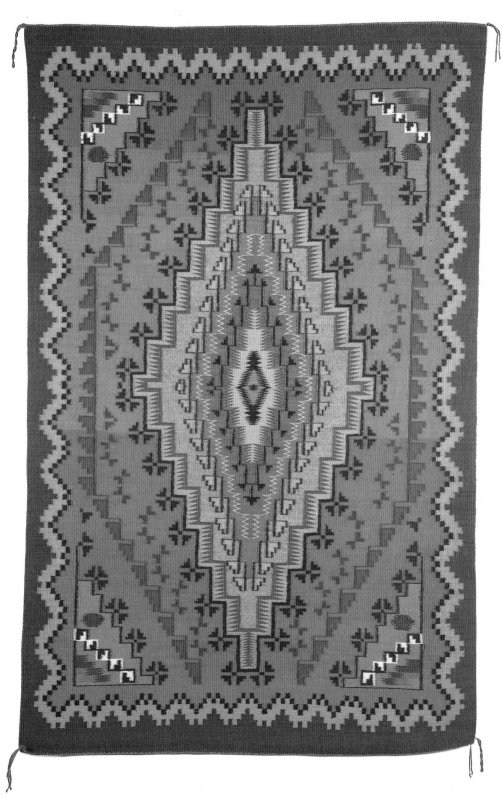

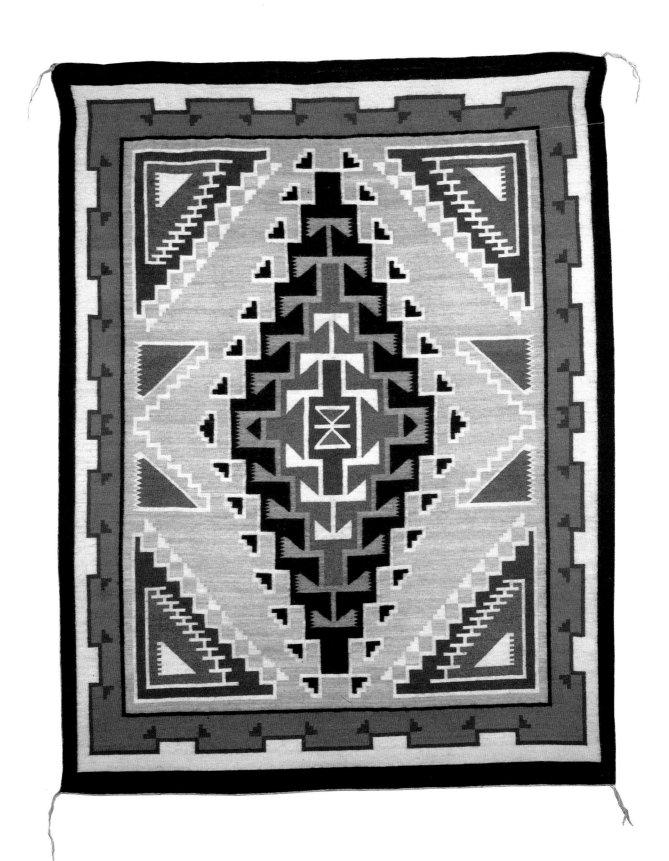

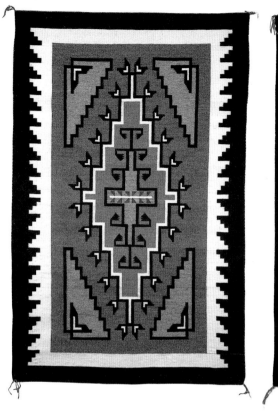

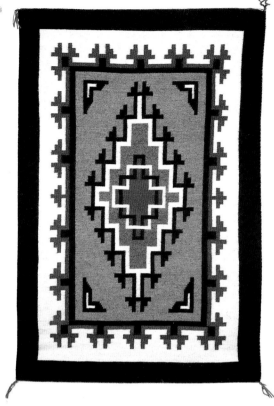

71

WEAVER	Daisy Taugelchee
LOCALE	Toadlena, New Mexico
DATE	ca. 1962
STYLE	Two Grey Hills
FUNCTION	Wall hanging
MATERIAL	Natural-dyed hand-spun yarn
LENGTH	47½ inches
WIDTH	37 inches
YARN COUNT	25 × 120

Made by the most famous Navajo weaver living today, this delicate super-fine weave with a remarkably high yarn count is an example of the best contemporary weaving. The balanced design, soft muted colors, and perfect angles are typical of the Two Grey Hills style. Such gauze-weight tapestries are translucent when held to the light. *(See also nos. 76 and 77.)*

72

WEAVER	Julia Jumbo
LOCALE	Toadlena, New Mexico
DATE	ca. 1985
STYLE	Two Grey Hills
FUNCTION	Wall hanging
MATERIAL	Hand-spun yarn
LENGTH	36 inches
WIDTH	23½ inches
YARN COUNT	23 × 100

By one of the half-dozen finest weavers in the Southwest, whose name is very well known to most textile collectors, this magnificent super-fine weave offers ample proof of the survival of Navajo attention to quality and beauty.

73

WEAVER	Julia Jumbo
LOCALE	Toadlena, New Mexico
DATE	ca. 1968
STYLE	Two Grey Hills
FUNCTION	Wall hanging
MATERIAL	Hand-spun yarn
LENGTH	34½ inches
WIDTH	23 inches
YARN COUNT	19 × 96

Far too delicate to be used on the floor or on a table, these beautiful works are intended solely for display as wall decorations; they have no Navajo function per se. The thread count is about average for this skilled weaver, whose work often will run over 100 to the inch.

74

WEAVER	Dorothy Mike
LOCALE	Toadlena, New Mexico
DATE	ca. 1977
STYLE	Two Grey Hills
FUNCTION	Wall hanging
MATERIAL	Hand-spun yarn
LENGTH	43 inches
WIDTH	26½ inches
YARN COUNT	21 × 82

Although not as tightly woven as no. 77, this is an extremely well-developed design, with a somewhat simpler combination of motifs in black, white, brown, and grey on a plain tan background.

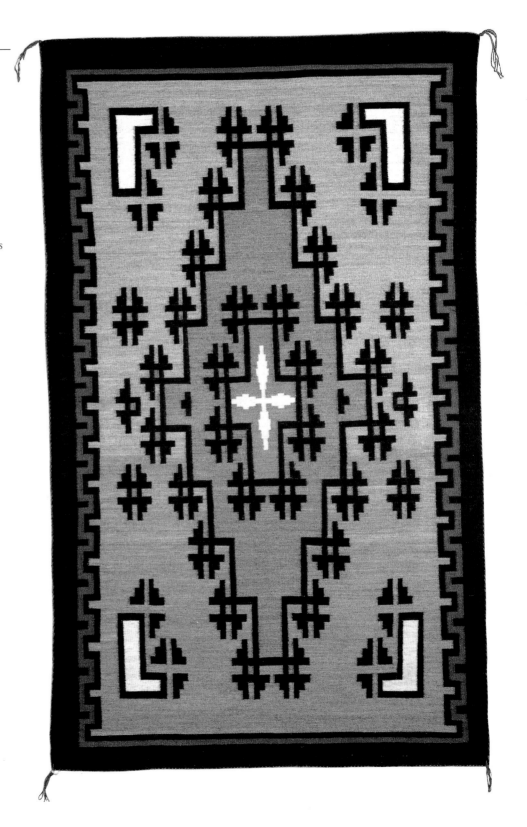

WEAVER	Virginia Deal
LOCALE	Toadlena, New Mexico
DATE	ca. 1985
STYLE	Two Grey Hills
FUNCTION	Wall hanging
MATERIAL	Hand-spun yarn
LENGTH	62 inches
WIDTH	41 ½ inches
YARN COUNT	15 × 100

A very finely woven example with the large central diamond element typical of Two Grey Hills tapestries, this has a relatively simple border. As with most textiles from this region, the weaver has included only five colors to achieve an effective design.

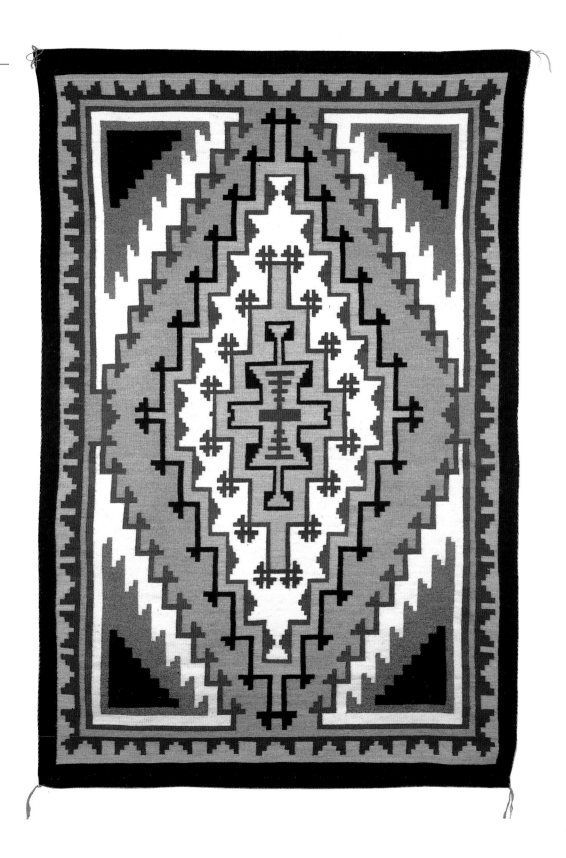

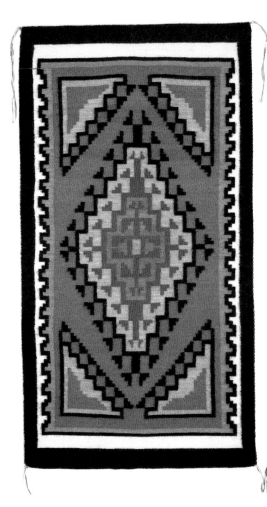
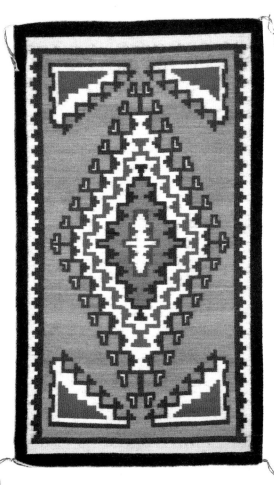

76

WEAVER	Priscilla Taugelchee
LOCALE	Toadlena, New Mexico
DATE	ca. 1985
STYLE	Two Grey Hills
FUNCTION	Wall hanging
MATERIAL	Hand-spun yarn
LENGTH	28½ inches
WIDTH	15½ inches
YARN COUNT	20 × 100

By the daughter-in-law of the famous Daisy Taugelchee, this equals her work in all respects. It is literally a piece of gauze; when held up to the light, these super-fine weaves have a magical transparency. *(See no. 71.)*

77

WEAVER	Priscilla Taugelchee
LOCALE	Toadlena, New Mexico
DATE	ca. 1985
STYLE	Two Grey Hills
FUNCTION	Wall hanging
MATERIAL	Hand-spun yarn
LENGTH	25½ inches
WIDTH	15 inches
YARN COUNT	24 × 146

Another remarkable textile by a member of the famed Taugelchee family, this super-fine weave in white and four shades of brown is the most finely woven textile in the exhibition, with a yarn count twice that of the classic wearing blankets made a century earlier. *(See no. 1.)*

78

WEAVER	Margaret Yazzie
LOCALE	Newcomb, New Mexico
DATE	ca. 1985
STYLE	Two Grey Hills
FUNCTION	Wall hanging
MATERIAL	Hand-spun yarn
LENGTH	44½ inches
WIDTH	28½ inches
YARN COUNT	19 × 125

Departing from the usual single-diamond design, this very finely balanced double-diamond design in shades of black, brown, grey, and white is another of the more remarkably high yarn counts in the exhibition.

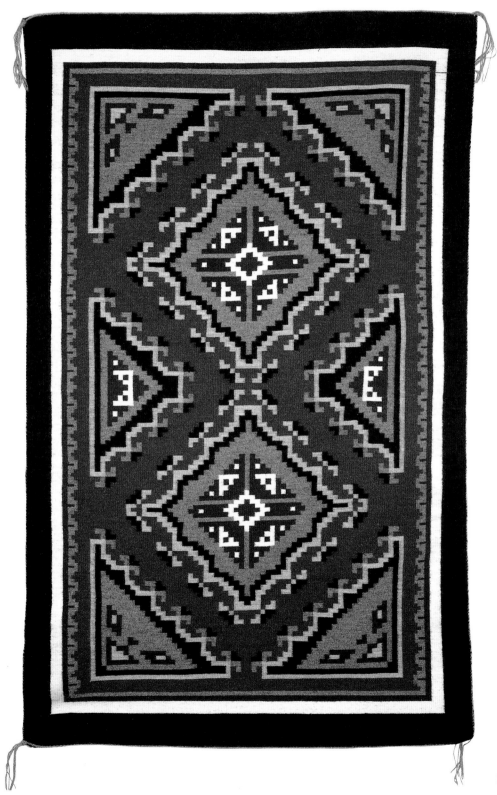

79

WEAVER	Margaret Yazzie
LOCALE	Newcomb, New Mexico
DATE	ca. 1985
STYLE	Two Grey Hills
FUNCTION	Wall hanging
MATERIAL	Hand-spun yarn
LENGTH	36½ inches
WIDTH	24½ inches
YARN COUNT	19 × 116

As the thread count indicates, this super-fine weave with double-diamond center is another example of the high quality of Navajo weaving today. It represents the kind of technical skill that has become typical of a wide range of weavers working in the Two Grey Hills style.

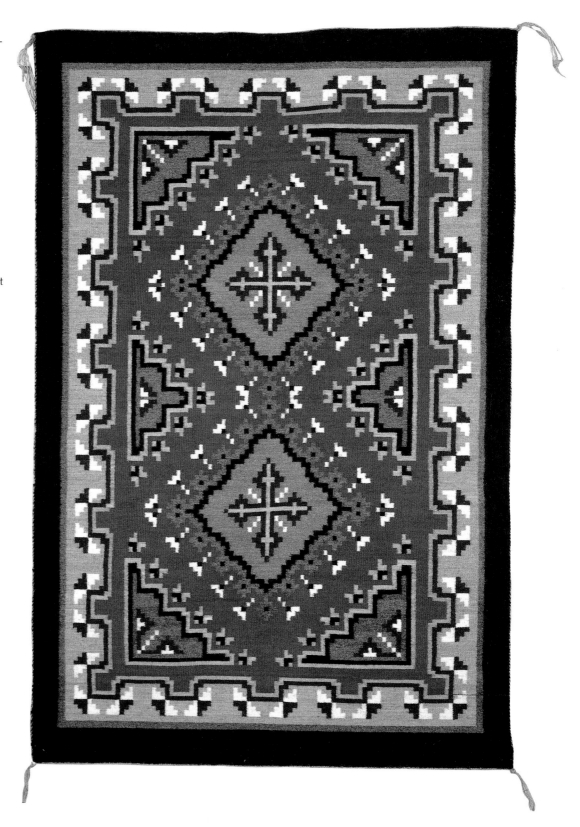

80

WEAVER	Marie Lapahie
LOCALE	Toadlena, New Mexico
DATE	ca. 1985
STYLE	Two Grey Hills
FUNCTION	Wall hanging
MATERIAL	Hand-spun yarn
LENGTH	60 inches
WIDTH	35½ inches
YARN COUNT	21 × 90

In this small super-fine weave, double-diamond elements familiar in Two Grey Hills designs are demonstrated to advantage. A departure here is the soft beige background in place of the more usual grey.

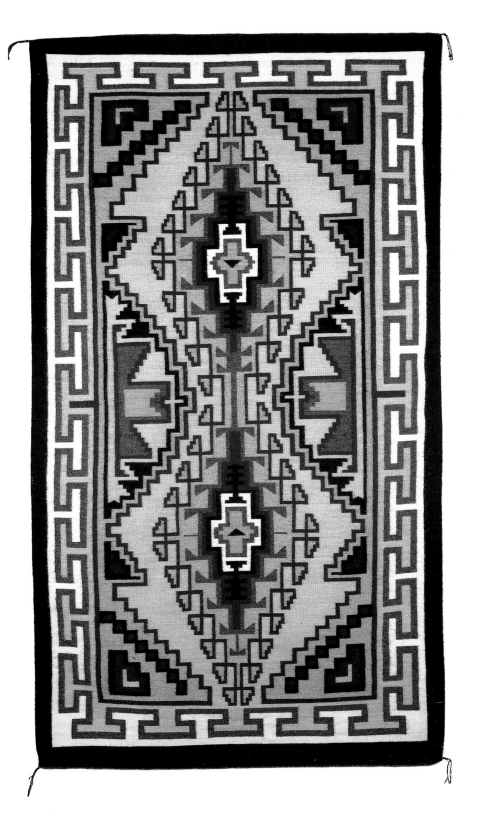

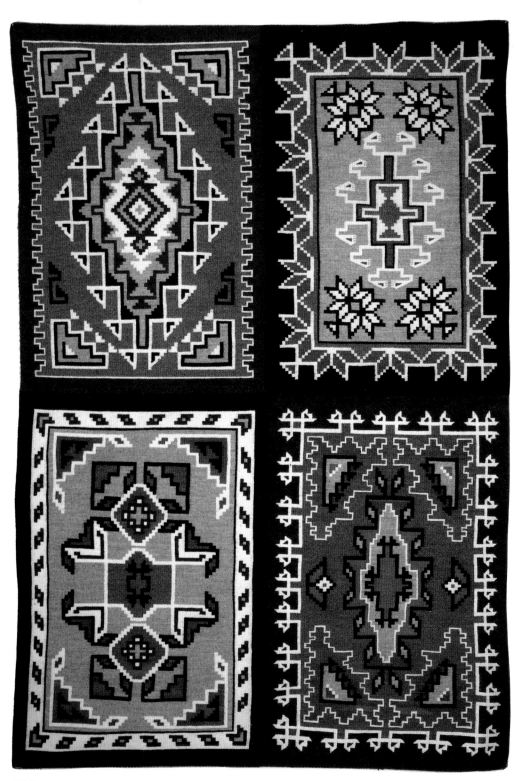

81

WEAVER	Anna Mae Tanner
LOCALE	Oak Springs, Arizona
DATE	ca. 1984
STYLE	Four-in-one
FUNCTION	Wall hanging
MATERIAL	Vegetal-dyed hand-spun yarn
LENGTH	69 inches
WIDTH	47 inches
YARN COUNT	17 × 54

A superb fine-weave tapestry, this sampler presents four basic design forms frequently employed in Two Grey Hills textiles. The sharply defined motifs, combined with the delicate weave, make it a *tour de force* of Navajo artistry. Although the designs are ornately worked, the use of only brown, white, black, and grey provides a singularly pleasing composition.

82

WEAVER	Anna Mae Tanner
LOCALE	Oak Springs, Arizona
DATE	ca. 1984
STYLE	Four-in-one
FUNCTION	Wall hanging; sampler
MATERIAL	Vegetal-dyed hand-spun yarn
LENGTH	64½ inches
WIDTH	52 inches
YARN COUNT	13 × 58

A far more complicated and more colorful combination of motifs—two panels of Four Corners designs combined with two pictorial panels (a *Yeíbichai* ritual and a group of Fox Dancers)—forms an intriguing collection of textile designs in one small package.

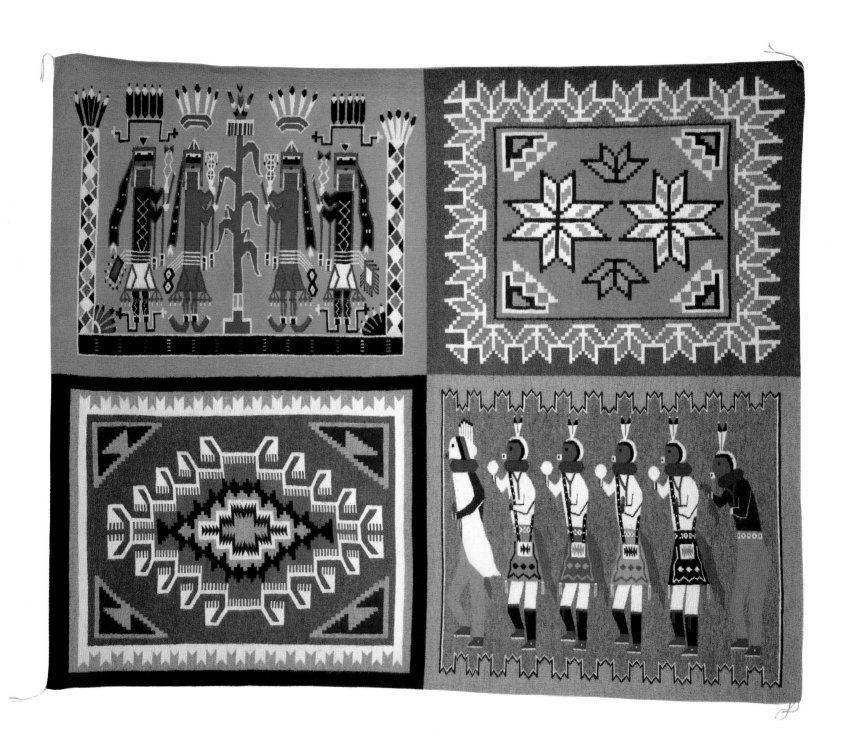

83

WEAVER	Unknown
LOCALE	Chinle (?), Arizona
DATE	ca. 1934
STYLE	Tapestry
FUNCTION	Floor rug
MATERIAL	Commercial yarn
LENGTH	53½ inches
WIDTH	34½ inches
YARN COUNT	12 × 30

This is a striking example of the Oriental influence: an Islamic prayer rug complete with *mihrab*, but by a Navajo artist. It is interesting to note that none of the elements included in this textile is basically Navajo. In use, the pointed end of the design is directed toward Mecca, to guide the Muslim in prayer. This rug was acquired from Tom Woodard, a present-day trader in Santa Fe, who indicates that it was one of two commissioned in 1934 by Clinton N. Cotton, a well-known Gallup trader, as a challenge to show that Navajo weavers could produce a textile design equal to Persian weaves. *

*Conversation with the author, 1 October 1986.

GLOSSARY

ANILINE An oily liquid derived from coal tar (today, usually nitrobenzene), invented in 1856, and widely used in making dyestuffs for textile manufacturing. Although there are still some weavers who prefer vegetal dyes (and are willing to take the time required to prepare them), aniline-based colors have largely replaced all other dyestuffs for Navajo weaving, due to their bright color range and resistance to fading.

BATTEN The flat wooden stick, or beater, which is used to open the SHED and to pack the weft threads tightly. Also called SWORD.

BAYETA (Spanish, "baize") A trade wool fabric highly prized by Navajo weavers for its attractive color, usually red, which could be unraveled and respun to provide an excellent weaving yarn. It was especially popular from about 1825 until the introduction of commercial yarns.

BIG FLY See DONTSO.

BILAGANA Navajo transliteration of "American"; hence, the general term used for "White man."

BOSQUE REDONDO (Spanish, "round grove") An area in De Baca County, New Mexico, near Fort Sumner, used as a concentration camp by Gen. James H. Carleton from 1863 to 1868 to confine the Navajo people after the Long Walk.

BURNTWATER A trading post north of Chambers, Arizona; an area where finely detailed, multicolored textiles are woven.

CEREMONIAL A term popularly applied to those textiles whose designs represent *Yei*, *Yeíbichai*, or sand-painting subjects. Also called CEREMONIAL RUG or CHANT WEAVE.

CHANT (*Hatal'*, Navajo) (1) Any of a group of Navajo religious ceremonies held for curing illness or alleviating pain. The term CHANT is derived from the singing that is a major part of the ritual. (2) A formalized musical prayer of the *hatali* conducting a given Navajo curing ceremony. Also called WAY.

CHANT WEAVE A term popularly applied to a textile whose design relates to a religious ceremony. The word "weave" is objectionable in that the reference is to a design, not a weave; it would be more accurate to call this a CHANT STYLE. Also called CEREMONIAL RUG.

CHIEF'S BLANKET A term commonly applied to a specific banded textile design, of which there are four principal patterns, called Phases. Chief's Blankets were not restricted to the use of chiefs (the Navajo do not have them), and the name is accurate only to the extent that such blankets were always expensive and therefore available primarily to wealthy or important persons. See also PHASE.

CHIMAYÓ (*Tsimayó*, Tewa, "obsidian") A non-Indian village in the Upper Río Grande area of Santa Fe County northeast of Santa Fe, New Mexico, founded by Tewa Indians. It was taken over in 1695 by Spanish settlers under De Vargas and subsequently expanded by Hispanic immigration. It is famous for well-woven treadle-loom textiles using commercial aniline-dyed four-ply yarns (particularly blankets, bed covers, and table runners), often mistaken for Navajo weaves.

CHURRO The Spanish sheep introduced into the Southwest in the sixteenth century. Modern Navajo sheep include a considerable *churro* strain, which has been inbred over the years.

CLASSIC A period in Navajo weaving history, ca. 1650–1865, when some of the earliest fine weaving was produced. It was marked by tightly woven fabrics, with terraced designs in bands or diamonds, but without the figures and the serrated, geometrical motifs that became popular later.

COAL MINE MESA A small area in Coconino County, Arizona, adjacent to the Hopi villages, where the Raised Outline technique was developed.

COYOTE CHANT (*Ma'iji*, Navajo) An old religious ritual, held to counteract insanity and prostitution; now extinct, although the ritual is still vaguely remembered by a very few older *hatali*.

CRYSTAL (*Tqunits'ili*, Navajo, "clear flowing water") 1. A village in San Juan County, northeastern New Mexico; the site of the J. B. Moore trading post, and where some of the finest modern vegetal-dyed textiles are woven today. 2. A design style characterized by "traditional" motifs introduced by Moore at the turn of the century. Subsequently a totally different form became popular, influenced by nearby Chinle and Wide Ruins success; this involved repeat horizontal bands of color without a border.

DINÉ (Navajo, "The People") The Navajo name for themselves. Also DINEH.

DIRECTIONAL Referring to the four directions: north, south, east, west.

DIYUGI (Navajo, "loose weave") A fluffy, loosely woven textile, usually quite thick, often used for saddle blankets. Also commonly called DOGIES, or DOUGIES.

DONTSO (Navajo, "big fly" or "Messenger Fly") Regarded as a messenger and a guard, and frequently used in sand paintings.

DOUBLE-FACED WEAVE A textile that is structurally identical on both faces. (A textile with a different pattern on each of its faces is more accurately known as a TWO-FACED WEAVE, *q.v.*)

DRY PAINTING Another name for a sand painting (although neither term is precise, as these are not technically paintings but are produced by pouring the finely ground pigments onto a flat surface). See SAND PAINTING.

DYE The substance used to color fibers, yarns, and fabrics. It may be created from recipes of synthetic, mineral, plant, or even insect matter.

EMERGENCE (*Hajiinei*, Navajo, "moving up") The place whence came all mankind; similar to the Pueblo *sipapú*. Also called EMERGENCE LAKE or EMERGENCE CENTER.

EYE DAZZLER A popular term applied to textile designs with brilliant colors and strong, contrasting zigzag or diamond elements, primarily of the Classic and Transitional periods. They were strongly influenced by Mexican *serape* designs.

FARMINGTON (*Tso'tsa*, Navajo, "between rivers") A town in San Juan County, northwestern New Mexico; at one time a major Navajo trading center.

FIRST PHASE The earliest Chief's Blanket design (ca. 1800–1850), consisting of parallel wide bands in black and white, occasionally with brown and indigo; sometimes a few thin red lines are added. See also CHIEF'S BLANKET; PHASE.

FLOAT A section of a warp or a weft passing over more than one unit of the opposite set of warps or wefts on either face.

FOUR CORNERS The only place in the U.S. where four states meet (Arizona, Colorado, New Mexico, Utah); an area on the Navajo Reservation that is home to many fine weavers.

FOUR SACRED MOUNTAINS The traditional boundary markers of the Navajo land (*Diné Biyaah*): *Dibentah* (north), *Tsodsil* (south), *Sisnadjini* (east), *Doko'oslid* (west).

FOURTH PHASE The last in sequence (ca. 1875–1900, but still occasionally woven) of the Chief's Blanket patterns, consisting of an elaboration of the terraced decorations in the corners and sides; these are often quite large ornamental patterns. See also CHIEF'S BLANKET; PHASE.

FRINGE MOUTH A major Navajo God, *Záhodolsha'ha*, particularly active in the Night Chant. The name derives from the fringing on the mask he wears.

GALLUP A town in McKinley County, New Mexico; a major gateway to the Navajo Reservation, and an important trading center.

GANADO (Spanish, "cattle herd"; in Navajo, *Luka n'kyel*, "wide reeds") A trading post in Apache County, northeastern Arizona, operated by Juan Lorenzo Hubbell from ca. 1876 to 1930. In the late 1890s it was the source of many of the best blankets, marked by a predominant use of red.

GERMANTOWN A town in Pennsylvania; the origin of the famous commercially spun and dyed yarns that were used to make the tightly woven textiles bearing that name.

GREAT STAR CHANT (*Só'tsoji Hatal*, Navajo) One of the major religious rites held to dispel illness.

HATALI (Navajo, "one who sings") The priest, healer, or medicine man who officiates at Navajo curing ceremonies. Also often popularly called a SINGER.

HOGÁN The traditional Navajo dwelling, a circular, earth-covered structure constructed of closely fitting logs. It is usually hexagonal or conical in shape, with a mound-shaped or domed roof.

HOUSE GOD The Navajo supernatural Being, *Haschéhogan*, who watches over the *hogán* and protects its inhabitants.

HUMPBACK GOD The Navajo Fertility Being, *Ga'askidi*; he carries seeds or corn pollen in his back pouch.

KALUGI (Navajo, "butterfly") In Navajo culture the butterfly symbolizes foolishness, vanity, temptation, or insanity.

KAYENTA (*Tye'nde*, Navajo, "animal trap"?) A trading post in Navajo County, northeastern Arizona; important as the source of many fine textiles made in the Lukachukai–Four Corners region.

KETAN A solid or hollow cylindrical-rod prayer stick or prayer feather; called a "ceremonial cigarette" by many early writers. Also spelled KETAHN.

KINTIEL (Navajo, "wide house") Wide Ruins, Arizona; trading post south of Ganado, noted for the revival of vegetal-dyed textiles. Also spelled KINTEEL.

KLAGETOH (Navajo, "muddy water") A trading post in Apache County, Arizona, located between Ganado and Wide Ruins. It is the origin of a rug heavily influenced by the black, red, grey, and white Ganado style, but usually in a more intricate design. It is often difficult to distinguish between the two.

LATCH HOOK A geometrical motif composed of short reversed lines extended from a central diamond, especially featured in textile designs created by J. B. Moore.

LIGHTNING WARP See PULLED WARP; WEDGE WEAVE.

LITTLE STAR CHANT (*Yaz'soji Hatal'*) A religious rite representing the smaller stars. When the stars had been placed by First Man, Coyote jumped in and scattered them around; that is why they are so irregular in the sky. This chant alleviates ailments caused by star-gazing and night illness.

LONG WALK The notorious capture and transferral of the Navajo from their homeland over more than three hundred miles on foot to Bosque Redondo in 1863. See also BOSQUE REDONDO.

LUKACHUKAI (Navajo, "patches of white reeds") Mountains in northeastern Arizona, and a region in which specific designs of many weaves are produced today, particularly *Yei* and *Yeíbichai*.

MERINO A sheep variety experimentally but unsuccessfully introduced by the Bureau of Indian Affairs in the 1930s to provide better meat and wool for the Navajo.

MIHRAB (Arabic) A rectangular design with a pointed decorative end representing the prayer niche in a building wall facing Mecca. It is featured on Islamic prayer rugs to direct the worshipper; the pointed end is always placed toward Mecca.

MOKI·(Originally, probably Navajo, "monkey"; in Hopi, "dead") (1) A derogatory name commonly applied to the Hopi by the Navajo, and used by Whites to refer to the Hopi in ignorance of its connotation. (2) Any of several banded-design blankets traditionally woven by Hopi weavers. (3) A type of Navajo textile design featuring white, black, and indigo bands, with red geometric motifs. It was influenced by early Pueblo weaving, especially Hopi, hence the name. Also spelled MOQUI.

NÁHOKOS (Navajo, "whirling") A rectangular four-armed design representing the log raft on which the Holy Twins floated; frequently used in sand paintings. Also called WHIRLING LOGS.

NAYÉNEZGANI (Navajo, "Slayer of Enemies") The Monster-Slayer God; a major Navajo deity who protects the people against evil, witchcraft, and other unseen dangers.

OAK SPRINGS (*Tyel'chinti*, Navajo, "clump of iris") A small settlement of fine weavers on the Arizona–New Mexico border.

PHASE A "design calendar" for Chief's Blankets suggested by Frederic H. Douglas in 1951. Divided into four major periods to identify singular design forms; this division is unfortunate in that it suggests a relatively abrupt change, when there was actually a slow development with considerable overlap. See FIRST, SECOND, THIRD, and FOURTH PHASE; CHIEF'S BLANKET. (A succinct summary of these various divisions is in Kent, 1985, pp. 53–54.)

PICTORIAL A rug whose subject matter is visually realistic, usually portraying people, animals, plants, or landscapes.

POLLEN BOY (*Tadidin'aki*, Navajo, "pollen on top") A sacred figure symbolic of male generation; often included in sand paintings.

POUND RUGS Textiles that were sold by the pound, reflective of the quality of weaving of the period 1900–1930.

PULLED WARP A weaving technique featuring zigzag patterns wherein the use of diagonal wefts pulls the warps out of their normal vertical alignment, resulting in irregular, slightly scalloped edges. Also called LIGHTNING RUG, LIGHTNING WARP, or WEDGE WEAVE.

RAINBOW (*Natsílid*, Navajo) In a sand painting, the encircling narrow bands (usually red, blue, and white), representing the Rainbow God, which act as a guardian against harm. The opening at one end is usually protected by a pair of DONTSOS, *q.v.*

RAISED OUTLINE A weaving technique that produces a pronounced ridge at the edges of the designs. It was developed in the area of Coal Mine Mesa, Arizona, ca. 1940–50.

RED ANT CHANT (*Wolachiji*, Navajo) A ceremony held to dispel body illnesses, particularly those related to lightning or caused by consuming anything that has been struck by lightning. It is also effective in curing insect bites, witchcraft, or evil dreams.

REVIVAL Referring to the period in Navajo weaving history ca. 1920–40, when successful efforts were made by several devoted individuals to restore Navajo weaving to its earlier splendor and quality.

SACRED MOUNTAINS See FOUR SACRED MOUNTAINS.

SADDLE BLANKET A heavy woven textile, used as a pad under a saddle to protect the horse's back. Single saddle pads measure about 30″ × 30″; double pads, about 30″ × 60″, are folded for use.

SALTILLO A town in the state of Coahuila, northern Mexico, where textiles featuring designs of serrated bands and diamonds were woven or marketed. Actually, not all of these *serapes* were produced in Saltillo; but since the town was a gathering center, its name became the generic reference to the textile. Traded to the north, these greatly influenced Navajo design of the early nineteenth century.

SAMPLER A textile that incorporates a wide variety of textile designs. Popular in the late nineteenth century, these may have been selection guides for customers, or directives to the weaver. They include twenty-four to forty-eight complete miniature rug designs in favor at the time, each in its own rectangular panel.

SAND PAINTING (*Ikhá*, Navajo) The colored images made of pulverized minerals and sands that accompany almost all Navajo religious ceremonies. Represented in chant-style textiles; see CHANT WEAVE. Also called DRY PAINTING.

SECOND PHASE A later (ca. 1860–80) Chief's Blanket design, in which the parallel bands have been elaborated with small rectangular red motifs (usually nine) in the corners and center of the field. See also CHIEF'S BLANKET; PHASE.

SERAPE The common Mexican man's wearing blanket (a rectangular textile worn over the shoulders). It is normally woven in two sections which are then sewn together lengthwise with a slit left in the center so it can be pulled over the head. It is still popular throughout Mexico. Also spelled SARAPE.

SHED The horizontal open section of the loom, created by turning the batten to permit the entry of weft yarn.

SHIPROCK (*Tse Bitai*, Navajo, "rock with wings") A trading post in northwestern New Mexico; named for a nearby geological upthrust. Many fine sand-painting rugs come from this area.

SINGER See HATALI.

SNAKE PROTECTOR (*Tlish hadaltego*, Navajo, "snake figure") In sand paintings, the serpentine designs representing the snake guardians; they are effective against snakebite and also ward off evil.

SPRUCE MOUNTAIN (*Chóol'ti*, Navajo) A hill near Gobernador, in the Río Arriba area of northern New Mexico.

STORM PATTERN A design with a large rectangular center connected to four smaller rectangles in the corners, popular with J. B. Moore, who introduced many variants of the design. There are many fanciful interpretations of the significance of the motif and its origin, but there seems little doubt that it was White-inspired.

SWORD See BATTEN.

TALKING GOD The Navajo "Grandfather God," *Hashchyelti*, who is a leader in the *Yeíbichai* ceremony and traditionally the only supernatural who talks to the people.

TAPESTRY WEAVE The standard Navajo over-and-under weave, in which the more closely spaced weft threads interlace, thus hiding the warp; and with designs formed by colored wefts that double back at the edges of each design area.

TEES NOS POS (*Tiísnazbas*, Navajo, "circle of cottonwood trees") A trading post in Apache County, northeastern Arizona; noted for a design style not unlike Two Grey Hills, but often more complicated and with more color. The designs are often termed "rugs within rugs." Also spelled TEEC NOS POS.

THIRD PHASE A later (ca. 1875–90) sequence of the Chief's Blanket design classification, in which the twelve red corner patches have been simplified into nine terraced diamond (or triangular) motifs in the corners, sides, and center of the striped field. See also CHIEF'S BLANKET; PHASE.

THROW A term common at the turn of the century referring to small-sized casual weaves, usually used to decorate tables, sofas, and taborets. They could be "thrown" anywhere for decorative or protective purposes.

TOADLENA (*Toh-halane*, Navajo, "bubbling water") A trading post and boarding school in San Juan County, New Mexico, near Two Grey Hills.

TRANSITIONAL A period in Navajo weaving history used by students to indicate the period of change (1865–95) from traditional (weavings influenced by and used for native wearing purposes) to more contemporary design forms (chiefly floor rugs intended for sale to Whites and influenced by trader- or Oriental-inspired motifs).

TUBA CITY (*Tso nánesdizi*, Navajo, "tangled waters") A small town in Coconino County, north-central Arizona; headquarters for health and administrative services to the Hopi and Navajo. Named for a Hopi, Chief Tuba of Oraibi.

TWILL WEAVE A type of simple weave in which the floats are in diagonal alignment.

TWO-FACED WEAVE A weave in which each face of the textile has a different design; often confused with DOUBLE-FACED WEAVE, *q.v.*

TWO GREY HILLS (*Bis da'leetso*, Navajo, "two yellow adobes") A trading post in San Juan County, near Newcomb, New Mexico; the center of some of the finest weaving on the Navajo Reservation, although not all weaving of that design comes from here. (Often incorrectly spelled "Two Gray Hills.")

VEGETAL DYE Dye colors obtained from plants; also called VEGETABLE DYE or NATURAL DYE. Sometimes the latter term is applied to dyes hand-ground from mineral pigments.

WARP The foundation strands, usually heavier, into which the weft fibers are interlaced. These are the basic (or initial) strings that are placed on the loom before weaving is begun.

WAY Another term for CHANT.

WEDGE WEAVE A zigzag motif resulting from the pulling of the warp, creating an uneven or zigzag effect on the edge of the textile. Also called PULLED WARP or LIGHTNING RUG.

WEFT The horizontal "cross threads" that interlace into the stationary warp strands on the loom frame. Also called WOOF.

WHIRLING LOGS See NÁHOKOS.

WIDE RUINS (*Kintiel* or *Kinteel*, Navajo, "big ruined city") A trading post in Apache County, Arizona, north of Chambers; locale of a major textile revival that continues to the present. Sallie and William Lippincott owned the post from 1938 to 1942 and developed a distinctive vegetal-dyed textile style that had a profound influence on contemporary Navajo weaving design.

YARN COUNT A standard measure of the tightness of a weave; calculated by counting the number of warp threads by the weft threads in a square inch of textile. An average Navajo rug count is about 15 × 60.

YEI (Navajo, "God") (1) A Navajo supernatural. (2) Popular term for a textile that portrays one or more of the Gods in dance posture.

YEIBA'AD The Navajo name for the female Goddesses. The males are known as YEIBA'ADA.

YEÍBICHAI (Navajo, "Grandfather," a reference to the leading participant, *Hashchyelti*, the Talking God) (1) The public performance at which the Navajo Gods appear and dance for the patient and the spectators, to bring blessings and good health. (2) Also a term for the textiles with patterns that depict the dancers; a favorite theme of Lukachukai and Shiprock weavers.

BIOGRAPHICAL NOTES

The following biographical accounts of the lives of some of the weavers in *Song of the Loom* have been provided through the dedicated efforts of several individuals: Troy and Edith Kennedy, of Red Rock Trading Post, Arizona; Anne and Arch H. Gould, of Grand Junction, Colorado; and the collector of the textiles in this exhibition. The Goulds drew up a short questionnaire, which was given by them and the Kennedys to as many weavers as could be contacted, in order to obtain basic biographical information from each of them. While care has been taken to try to establish the accuracy of the data that were collected, it should be kept in mind that some of the women are now in their late seventies or early eighties; as several do not speak English, their children provided written translations. All quotations are the words of the weavers, although there has been some editing in an effort to maintain a uniform style. It is hoped that, in addition to providing some interesting insights into the feelings of the weavers, these comments will create a helpful human touch to the exhibition. This is not a selective group; these are the only such sketches that were available for inclusion in this catalogue.

It should be noted that the locality given with each sketch is the present home of the weaver, as far as can be determined (it may or may not be the same as her birthplace). Many of these families are still somewhat nomadic and frequently move about on the Reservation.

VERA BEGAY
Oak Springs, Arizona

Now sixty-five years old, Mrs. Begay was born at Oak Springs and has lived there all her life. There were three children in her family; she had a typical Navajo childhood, helping with the household chores and herding sheep. She started weaving at the age of fifteen, having learned entirely from her mother and by watching other weavers. Her first textile was a saddle blanket, which she refused to sell and still owns. She was active in the Girl Scouts of America when she was in school. Her greatest source of inspiration has been "trying hard and when the traders pay me a good price for a good rug. They tell me what people want and I try to weave it. My husband was a medicine man and he would tell me how to weave a sand painting." Asked what she felt had contributed most to her weaving, she gave a reply that is typical among the weavers: "Always getting a high price; I continue to weave to help support myself, and that's all I know how to do." (*Cat. no. 48*)

HELEN BURBANK
Chinle, Arizona

Mrs. Burbank was born near Ganado, one of twelve children, and attended Canyon de Chelly School. She learned to weave from her aunt and grandmother and wove her first rug when she was eight years old; it was sold for $15. "I prefer to do *Yeibichai* rugs, but I also enjoy other designs as well," she says. With the acquisition of a pickup truck, providing wider communication, Helen, along with many of the younger weavers, is beginning to forgo the traditional regional style by incorporating the features of other types of rugs. This development has led to a composite style—a "Reservation Rug," so to speak, which no longer reflects the restrictions of geography or local design conventions. *(Cat. no. 21)*

VIRGINIA DEAL
Toadlena, New Mexico

Now fifty-eight years old, Virginia Deal was born at Toadlena, where she has lived all her life. She had four sisters and six brothers. She went to school and completed the sixth grade. She learned how to weave by helping her mother finish off her rugs, and she wove her own first rug at the age of thirteen: a 20-by-36-inch textile which she sold to Willard Leighton at Two Grey Hills Trading Post for $17. Her sisters Elizabeth Mute and Marie Lapahie are equally famous as fine weavers. She has a daughter, Caralena, now twenty-two, who is also becoming a full-time weaver. Her present ambition is to create a large rug that will allow her to make a down payment on a new pickup truck—now becoming a major factor in the changes in Navajo weaving. *(Cat. no. 75)*

BESSIE GEORGE
Wide Ruins, Arizona

Born about 1932 at Wide Ruins, Bessie George has lived there all her life. She has two brothers and two sisters; one of the latter also weaves. Her mother taught her to weave; she sold her first rug for $7, but does not remember exactly when that was. She attended school and finished sixth grade, and then married; she has fifteen children, only one of whom follows her mother's art. The most she was ever paid for a rug was $1,800. She is a regular weaver, supporting her family by her efforts. *(Cat. no. 25)*

GRACE JOE
Red Valley, Arizona

Now seventy-nine years old, Mrs. Joe was born in Red Valley and has lived there most of her life. There were four children in the family, and she worked around the house during her youth; she had no schooling and married when she was very young. She wove her first rug when she was twenty years old; it was a large *Yeíbichai* textile which she sold at the Red Rock Trading Post for $60.

Her aunt Louise Chee taught her how to weave, and her mother helped her improve her weaving. When asked what is needed most to keep people weaving, she succinctly replied, "More money to pay for the rug. We never know how things will be in the future; weaving rugs might be the only way they might support themselves and their families. This is the only way I support myself, buying groceries and paying for some other things, like my truck and clothes for my family." *(Cat. nos. 50, 51, and 52)*

JULIA JUMBO
Toadlena, New Mexico

This famous weaver was born at Newcomb, New Mexico, and is now fifty-eight years old. She has one brother. She was about twenty years old when she wove her first rug, which her mother sold for her to the Newcomb Trading Post. Since then she has had continued success; she has received as much as $5,500 for her work. She herds her own flock, does her own shearing, and prepares the wool herself for weaving the textiles, many of which go to the Shiprock Trading Post. Although her children used to weave, they no longer do so. Today she specializes in the small 2-by-4-foot super-fine textiles. *(Cat. nos. 72 and 73)*

MARIE LAPAHIE
Toadlena, New Mexico

Now forty-nine years old, Mrs. Lapahie learned to weave from the famous Daisy Taugelchee. She did her first weaving at the age of ten, but she does not remember much about it; at the age of fifteen she wove a rug which was sold to Derald Stock of the Two Grey Hills Trading Post. She attributes the faint pink shade of her wool, for which she has become noted, to the use of the belly wool of a newborn lamb. Her sisters Virginia Deal and Elizabeth Mute are also known as excellent weavers. *(Cat. no. 80)*

ANGIE MALONEY
Tuba City, Arizona

Now thirty-six years old, Angie Maloney was born in Sand Springs, Arizona, and has lived there or in Tuba City all her life. In a family of seven children, she has one other sister who is a weaver but who is relatively inactive now. Her father is a *hatali*. Her first interest in weaving was at the age of six, learning the art from her mother, Dorothy Walker, a prominent weaver of four-in-one textiles. She wove her first rug at the age of eight: a 2-by-3-foot rug which she sold at the Oraibi Trading Post. Having begun weaving actively as a means of support for her family, she usually produces about four rugs a year, working as time permits. The single example of her work in the exhibition was judged Best of Show and Best of Its Kind at the 1979 Gallup Indian Ceremonial; she wove it during her last two years at college. She was supported financially by a collector during this period so she could complete her education; she also gave birth to her second child.

Mrs. Maloney earned a B.S. in Microbiology and Environmental Science at Northern Arizona University in Flagstaff; at present she is Director of Environmental Health Services at the Tuba City Regional Public Health Facility. She plans to resign from her medical position, "take my first vacation since I was six years old, finish my Master's Degree, be with my three children, and weave another large tapestry." One daughter is being taught to weave. *(Cat. no. 62)*

DOROTHY MIKE
Toadlena, New Mexico

Now sixty-three years old, Dorothy Mike was born at Toadlena, where she has lived all her life. She was taught to weave by her mother, and she wove her first rug when she was thirteen; she did not sell it, because her father kept it. "I gradually improved my weaving; my last rug was in 1977. I had to stop because of a back hurt when lifting a sheep." Her sister-in-law, Rose Mike, is also a well-known tapestry weaver. *(Cat. no. 74)*

DESPAH NEZ
Oak Springs, Arizona

This major weaver is now seventy-nine years old. She was born at Black Rock, New Mexico, and has lived most of her life at Oak Springs. She was one of two children. She first became interested in weaving at the age of twelve, learning from her stepmother; she credits traders and good prices as being the most important influences upon her weaving: "I got interested in weaving after I returned from school. I had asked my father to put me in school when I was nine years old. I used to herd the sheep with my cousin; her name is Evelyn Clah Chee. Evelyn and I went to the Shiprock Indian Agency Boarding School. I started school March 1918. I stayed in school until I finished fourth grade. In 1922, seven of us went to the Phoenix Indian School, where I stayed for another four years. Pass to ninth grade. I never went back to school, as I was needed at home to help take care of my father. It was at this time I began to weave. I wove a *Yei* rug; it was 3 feet by 4 feet. I sold it to Shiprock Trading Post to Mr. Ralph Evans; received $3 for it. My two daughters and I have been selling our rugs to Edith and Troy Kennedy. They are the best traders we ever had; they keep us selling our rugs to collectors. I'm getting old for this kind of weaving. But I like to weave and do not have anything else to do." *(Cat. nos. 31, 33, 39, 41, 43, and 53)*

MAGGIE PRICE

Sanders, Arizona

Now fifty-two years old, Maggie Price was born at Sanders, where she has lived all her life. She has two brothers and two sisters; all of the women are good weavers. Mrs. Price wove her first rug in 1953, when she was nineteen: a 3-by-4-foot rug for which she received $600. She usually turns out two to four rugs a year, and has produced about 100 textiles during her career. Her daughter is also a fine weaver. One indication of their success can be measured by their ownership of a $33,000 van. *(Cat. no. 69)*

DAISY REDHORSE

Crystal, New Mexico

Daisy Redhorse, who died of cancer at about the age of forty, was the daughter of Nellie Williams, who is now seventy-five and almost blind, but still weaving. Nellie taught Daisy and her two sisters, Katie Wauneka and Betty Jumbo, the art of two-faced weaving. These three women are among the very few remaining weavers who continue the tradition of two-faced weaves. *(Cat. no. 22)*

ANNA MAE TANNER

Oak Springs, Arizona

Mrs. Tanner, the weaver whose work is most heavily represented in this exhibition, dictated her reply to her daughter.

"My name is Anna Mae Tanner. I'm fifty-eight years old. I was born in Phoenix, Arizona, and raised on the Navajo Reservation in Oak Springs, Arizona. I'm half Hopi and Navajo. I was six years old when I was forced to weave by my mother. I did not have a choice. I watched my mother, Desbah G. Nez [sic], how she wove her rug, but really I taught myself how to weave.

"When I was growing up I never played or had schooling. Much of my early life I had a lot of work to do, spinning yarn, washing clothes for my younger brothers and sisters, bringing water back to the house.

"When I was weaving my first rug, I had the hardest time of my life. I cried because it didn't look pretty and my designs were too simple. I was six years old; it was about one or two feet in width and length. It was a *Yei*-type rug. It was sold at Shiprock Trading Post and I received one jar of peanut butter.

"I used to stay awake late into the night thinking of the designs that I would make on the rug.

"The one thing that has improved my weaving is when I got married and had several children, there was a trader from Cortez [Colorado] came around to the Oak Springs area and gave us two pictures of sand paintings and thereafter we started to weave sand-painting rugs.

"Then Edith and Troy Kennedy brought books with sand-painting ceremonial pictures and they

gave me books and told me which rugs collectors wanted to buy. Most of my rugs I sold to Troy Kennedy, but I sold a few to a collector in Arizona.

"I think advertising of certain sand-painting rugs with prices on them at local museums would be good. I think money is needed most to keep weavers weaving. Weaving is very hard and it takes many hours to weave the fine weaving. It takes a lot of time, energy, both mentally and physically.

"I continue to weave because this is the only source of income, because I didn't have much education. I have to pay for my house and my car. Troy Kennedy gives me loans to take care of my electric and other needs. I get sick on and off because I'm a diabetic and losing my eyesight. But I must continue, for this is my way of life, my income." *(Cat. nos. 34, 37, 38, 44, 46, 54–57, 81, and 82)*

PRISCILLA TAUGELCHEE
Toadlena, New Mexico

Now forty years old, Priscilla Taugelchee was born near Tonalea, Arizona. She is one of six children; none of the others in her family is a weaver. She attended Tonalea School, finishing her education at Choctaw Boarding School in Oklahoma. She was taught to weave by her mother, and later by her mother-in-law, Daisy Taugelchee. She has made the most of this

fine training, and today Priscilla and Daisy Tangelchee are widely regarded as among the very best of the Two Grey Hills artists. Her first rug was sold to Russell Foutz at Farmington for $100. She has one son. *(Cat. nos. 76 and 77)*

ALBERTA THOMAS
Oak Springs, Arizona

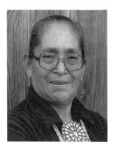

Now fifty-six years old, Mrs. Thomas was one of seven children; she has lived at Oak Springs all her life. She credits her mother, Despah Nez, and her sister Anna Mae Tanner, who taught her the art of weaving, as her greatest influences. These three well-known weavers have provided a majority of the textiles in *Song of the Loom*.

As a child, Mrs. Thomas completed first grade at school, helped around the house, and herded sheep. She wove her first rug at the age of ten, an 18-by-24-inch *Yei* piece which she sold at the Shiprock Trading Post for $5. She places a high value on the encouragement of the Kennedys, and of the collector of *Song of the Loom*, of whom she says: "He bought most of my rugs from Red Rock Trading Post; he pays me a good price and then he would send me a bonus if the rug was extra good. Troy always let my family charge at the store. I bought my first pickup with rug money."

Asked what is the most important help non-weavers can provide, Mrs. Thomas replied, "Educating people to buy rugs, for the prices for rugs to stay high, and to buy rugs even if they are not always very good. I continue to weave to help buy the things we need, such as groceries, pickups, plus I also enjoy it." *(Cat. nos. 35, 36, 40, 42, 45, 47, and 49)*

KATIE WAUNEKA
Fort Defiance, Arizona

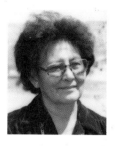

The sister of Daisy Redhorse and Betty Jumbo, Katie Wauneka is now about forty-six years old. She was born near Fort Defiance, and she learned how to weave from her mother, Nellie Williams. She wove her first rug at the age of seven and has worked at the loom ever since. She prefers vegetal-dyed yarns, and she and her sisters gather their own dyestuffs. "The most I ever got for a rug was $2,000. I weave because I enjoy it, and also for the money." *(Cat. no. 28)*

BETTY JOE YAZZIE
Red Rock, Arizona

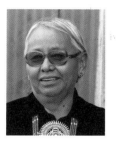

Betty Joe Yazzie is now fifty-five years old, and has always lived at Red Rock. There were ten children in her family, and she started weaving at the age of seven. Her mother, Grace Joe, was her only teacher. "I herded sheep most of my early life, until I got married; then I took care of my family, and I wove every once in a while until, about 1970, I became a regular rug weaver. I had only one year of schooling." She wove her first rug when she was eight years old; it was a 6-by-10-inch textile, which she still has. She learned simply by watching other weavers; her mother was the greatest influence on her weaving. She feels she will improve best by following her own interests and concentrating on her work.

She is another weaver who realizes that a major factor in keeping people active is a better economic return for their work. "Have more interest in some of the young weavers; tell them what you really want to see in the rugs." When asked her reason for weaving, she replied, "That's the only way I earn extra money to support myself, and I enjoy weaving. When I don't weave, I feel sick. When we weave, we feel good." *(Cat. no. 64)*

MARGARET YAZZIE
Newcomb, New Mexico

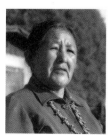

[Most of this account is taken from a sketch provided by the daughter of Mrs. Yazzie, Sarah Zah.] Margaret Yazzie was born April 8, 1929, just north of Newcomb Trading Post; she is now fifty-seven years old. She comes from a large family, with five sisters and five brothers. Her father died when she was one year old, and she was raised by her foster grandmother, Adzani Baah, an experienced weaver. Mrs. Yazzie attended school for only one year and spent most of her childhood herding sheep and horses. She learned to weave by watching her grandmother, and has an early memory of picking the wool off the bushes and learning to spin it. Her first rug, a 3-by-5-foot floor throw, was sold to Willard Leighton at the Two Grey Hills Trading Post for about $15; but she regards his successor, Derald Stock, as the person who really started her career by encouraging her work and providing a market for her textiles.

As she says, "The tradition of weaving in my family is up to my daughters. They have to have the urge to weave. I can only continue to encourage them to weave during their spare time. They are all employed as well as their husbands; there is little need to weave because of employment. As for me, it was the only source of income for my family, and it's still true today. I also have an added responsibility of caring for my grandchildren so my children can work and tending to my own household chores, which

takes time away from my weaving. Most of my weaving is done at night. The strain of looking at the warp constantly has taken its toll on my eyesight. My vision was corrected with eyeglasses, which allows me to continue to weave. It has not been easy to weave by artificial light at night with these eyeglasses. I greatly appreciate the opportunity to share my lifelong endeavor to maintain weaving as an art and also a means of income for our people." Today she is regarded as one of the better weavers on the Reservation. (*Cat. nos. 78 and 79*)

PHILOMENA YAZZIE
Sanders, Arizona

Regarded as the best of the weavers working in the complex Burntwater style, Mrs. Yazzie has lived all of her life in Sanders. She is now forty-four years old, and with her sister is a frequent prize winner at various exhibitions and fairs. She learned by watching her mother, and wove her first textile (a two-faced rug) at the age of fifteen. She has five children, one of whom, Delores Grisley, is developing into an expert weaver in her own right. Philomena tends her own flocks, shearing the sheep, dyeing the wool, and doing her own spinning, all in the traditional way.

At present, she works full time at the local school as a kitchen helper. When she gets home in the afternoon, she does her chores (household and sheep-corral duties), then sits at the loom until well after midnight. She usually produces two 4-by-6-foot rugs a year; today these will sell for $5,000 to $6,000 each. In response to the question of where her design ideas originate, she says, "I just start weaving and the rug tells me what to do." (*Cat. no. 70*)

BIBLIOGRAPHY

The following sources have been used in the preparation of this catalogue, or will be of particular interest in any study of the art of the Navajo weaver.

ADAMS, WILLIAM V. *Shonto: A Study of the Role of the Trader in a Modern Navaho Community.* Smithsonian Institution, Bureau of American Ethnology Bulletin no. 188. Washington, D.C., 1963. 268 pp.

AMSDEN, CHARLES A. *Navaho Weaving: Its Technic and History.* Santa Barbara: Fine Arts Press, 1934. 261pp.

————. "Reviving the Navaho Blanket." *Masterkey* (Southwest Museum, Los Angeles), vol. 6 (1932), pp. 137–49.

————. "When the Navaho Rugs Were Blankets." *School Arts Magazine,* vol. 34 (1935), pp. 387–96.

BAHTI, MARK. *A Consumer's Guide to Southwestern Indian Arts and Crafts.* Tucson: Bahti Indian Arts, 1954. n.p.

BAHTI, TOM. *Southwestern Indian Arts and Crafts.* Flagstaff: KC Publications, 1966. 32 pp.

BARTLETT, KATHERINE. "Present Trends in Weaving on the Western Navajo Reservation." *Plateau* (Museum of Northern Arizona, Flagstaff), vol. 23 (1950), pp. 1–5.

BENNETT, NOËL. *The Weaver's Pathway.* Flagstaff: Northland Press, 1974. 64 pp.

————, and TINA BIGHORSE. *Working with the Wool.* Flagstaff: Northland Press, 1971. 105 pp.

BERLANT, ANTHONY, and MARY H. KAHLENBERG. *Walk in Beauty: The Navajo and Their Blankets.* Boston: New York Graphic Society, 1977. 167 pp.

BLUNN, CECIL T. "Navaho Sheep." *Journal of Heredity,* vol. 31 (1940), pp. 99–112.

BOYD, DOROTHY E. "Navajo Pictorial Weaving: Its Past and Its Present Condition." Master's thesis, University of New Mexico, 1970. 149 pp.

BRUGGE, DAVID M. "Imitation Navajo Rugs." *Washington Archaeologist* (Washington, D.C.), vol. 16 (1972), pp. 1–3.

————, and CHARLOTTE J. FRISBIE, eds. *Navajo Religion and Culture: Selected Views.* Santa Fe: Museum of New Mexico, 1982. 249 pp.

BRYAN, NONABAH, and STELLA YOUNG. *Navajo Native Dyes: Their Preparation and Use.* Washington, D.C.: Bureau of Indian Affairs, 1940. 75 pp.

CASEY, PEARLE R. "Chimayó, the Ageless Village." *Southwestern Lore* (Boulder, Colo.), vol. 1 (1936), pp. 12–13.

CERNY, CHARLENE. *Navajo Pictorial Weaving.* Santa Fe: Museum of New Mexico, 1975. 37pp.

COLE, ELLIS P. "Navajo Weaving with Two- or Four-harness Looms." *Weaver,* vol. 2 (1937), pp. 11–13.

COLTON, MARY-RUSSELL F. "Wool for Our Weavers—What Shall It Be?" *Museum Notes* (Museum of Northern Arizona, Flagstaff), vol. 4 (1932), pp. 3–5.

CONNER, VEDA N. "The Weavers of Chimayó." *New Mexico Magazine*, vol. 29 (1951), pp. 19ff.

COOLIDGE, DANE, and MARY COOLIDGE. *The Navajo Indians*. Boston: Houghton Mifflin, 1930. 309 pp.

DEDERA, DON. *Navajo Rugs*. Flagstaff: Northland Press, 1975. 114 pp.

DOCKSTADER, FREDERICK J. "The Marketing of Southwestern Textiles." In Emery and Fiske, eds., *Ethnographic Textiles of the Western Hemisphere*, 1977, pp. 467–76.

———. "Technique, Tradition and Trade." In Wheat, ed., *Patterns and Sources of Native Weaving*, 1978, pp. 71–79.

———. *Weaving Arts of the North American Indians*. New York: Thomas Y. Crowell, 1978. 223 pp.

DUTTON, BERTHA P. *Navajo Weaving Today*. Santa Fe: Museum of New Mexico, 1961. 40 pp.

EMERY, IRENE, and PATRICIA FISKE, eds. *Ethnographic Textiles of the Western Hemisphere*. Washington, D.C.: The Textile Museum, 1977. 535 pp.

ERICKSON, JON T., and H. THOMAS CAIN. *Navajo Textiles from the Read Mullan Collection*. Phoenix: Heard Museum, 1976. 80 pp.

GODDARD, PLINY E. "Navaho Blankets." *American Museum Journal*, vol. 10 (1910), pp. 201–11.

GOODMAN, JAMES M. *The Navajo Atlas: Environment, Resources, People, and History of the Diné Bikeyah*. Norman: University of Oklahoma Press, 1982. 109 pp.

GRANDSTAFF, JAMES O. *Wool Characteristics in Relation to Navaho Weaving*. U.S. Department of Agriculture, Technical Bulletin no. 790. Washington, D.C., 1942. 36 pp.

GREEN, EDWARD C. "Navajo Rugs." *Southwestern Lore* (Boulder, Colo.), vol. 24 (1958), pp. 17–24.

HEDLUND, ANN L. "Contemporary Navajo Weaving: An Ethnography of a Native Craft." Ph.D. thesis, University of Colorado, 1983.

HEGEMANN, ELIZABETH C. *Navajo Trading Days*. Albuquerque: University of New Mexico, 1963. 388 pp.

HOLLISTER, URIAH S. *The Navajo and His Blanket*. Denver: H. H. Tannen, 1903. 144 pp.

JAMES, GEORGE W. *Indian Blankets and Their Makers*. Chicago: A. C. McClurg, 1914. 213 pp.

JAMES, H. L. *Posts and Rugs: The Story of Navajo Rugs and Their Homes*. Globe, Ariz.: Southwestern Parks & Monuments Association, 1976. 126 pp.

———. "The Romance of Navajo Weaving." *New Mexico Magazine*, vol. 52 (1954), 8 pp.

JONES, COURTNEY R. "Spindle-spinning Navajo Style." *Plateau* (Museum of Northern Arizona, Flagstaff), vol. 18 (1946), pp. 43–51.

KAHLENBERG, MARY H. *The Navajo Blanket*. New York: Praeger, 1972. 112 pp.

KENT, KATE PECK. "The Cultivation and Weaving of Cotton in the Prehistoric Southwestern United States." *Transactions of the American Philosophical Society*, Philadelphia, vol. 47 (1957), pp. 457–732.

———. "From Blanket to Rug; The Evolution of Navajo Weaving after 1880." *Plateau* (Museum of Northern Arizona, Flagstaff), vol. 52 (1981), pp. 10–21.

———. *Navajo Weaving: Three Centuries of Change*. Santa Fe: School of American Research, 1985. 139 pp.

———. *The Story of Navaho Weaving*. Phoenix: Heard Museum, 1961. 48 pp.

KING, JEFF. *Where the Two Came to Their Father*. New York: Pantheon, 1943.

KISSELL, MARY L. "Aboriginal American Weaving." *Transactions of the National Association of Cotton Manufacturers*, vol. 88 (1910), pp. 195–215.

KLAH, HASTEEN. *Navajo Creation Myth*. Santa Fe: Museum of Navajo Ceremonial Art, 1942. 237 pp.

KLUCKHOHN, CLYDE, and LELAND C. WYMAN. "An Introduction to Navaho Chant Practice." *American Anthropologist*, Memoir no. 53, 1940. 204 pp.

LAUGHLIN, RUTH A. "The Craft of Chimayó." *El Palacio* (Museum of New Mexico, Santa Fe), vol. 28 (1930), pp. 161–73.

LUOMALA, KATHERINE. "Navajo Weaving." *El Palacio* (Museum of New Mexico, Santa Fe), vol. 80 (1974), pp. 161–73.

MCGREEVY, SUSAN B. *Woven Holy People: Navajo Sandpainting Textiles*. Santa Fe: Wheelwright Museum, 1982, n.p.

MCNITT, FRANK. *The Indian Traders*. Norman: University of Oklahoma Press, 1962. 393 pp.

———. "Two Gray Hills—America's Costliest Rugs." *New Mexico Magazine*, vol. 37 (1959).

MATTHEWS, WASHINGTON. "The Mountain Chant: A Navajo Ceremony." In Smithsonian Institution, Bureau of American Ethnology, *Fifth Annual Report*. Washington, D.C., 1887, pp. 379–467.

———. "Mythic Dry-paintings of the Navajos." *American Naturalist*, vol. 19 (1885), pp. 931–39.

———. "Navajo Dye Stuffs." In Smithsonian Institution, Bureau of American Ethnology, *Ninth Annual Report*. Washington, D.C., 1891, pp. 613–15.

———. "Navajo Weavers." In Smithsonian Institution, Bureau of American Ethnology, *Third Annual Report*. Washington, D.C., 1885, pp. 371–91.

———. "A Two-faced Navajo Blanket." *American Anthropologist*, vol. 2 (1900), pp. 638–42.

MAXWELL, GILBERT S. *Navajo Rugs: Past, Present and Future*. Santa Fe: Heritage Art, 1984. 99 pp.

MERA, HARRY P. *The Alfred I. Barton Collection of Southwestern Textiles*. Santa Fe: San Vicente Foundation, 1949. 102 pp.

———. *Navajo Textile Arts*. Santa Fe: Laboratory of Anthropology, 1947. 102 pp.

MERRY, EDWARD S. "So You Want to Buy a Navajo Rug?" *Indian Life*, vol. 38 (1960), pp. 30–35.

MOORE, JOHN BRADFORD. *The Navajo*. Crystal, N.M.: Published by the author, 1911. 32 pp.

NEWCOMB, FRANC J. *Hosteen Klah: Navaho Medicine Man and Sand Painter*. Norman: University of Oklahoma Press, 1964. 227 pp.

———. *Sandpaintings of the Navajo Shooting Chant*. New York: J. J. Augustin, 1937. 87 pp. + 35 plates.

———, STANLEY FISHLER, and MARY C. WHEELWRIGHT. *A Study of Navajo Symbolism. Peabody Museum Papers*, vol. 32, no. 3. Cambridge, Mass., 1956. 100 pp.

PAREZO, NANCY J. *Navajo Sandpaintings: From Religious Act to Commercial Art*. Tucson: University of Arizona Press, 1983. 251 pp.

PENDLETON, MARY. *Navajo and Hopi Weaving Techniques*. New York: Macmillan, 1974. 158 pp.

PEPPER, GEORGE. "The Making of a Navaho Blanket." *Everybody's Magazine* (1902), pp. 23–56.

———. "Native Navajo Dyes." *The Papoose*, vol. 1 (1903), pp. 1–11.

REICHARD, GLADYS. "Color in Navajo Weaving." *Arizona Historical Review*, vol. 12 (1936), pp. 19–30.

———. *Dezba, Woman of the Desert*. New York: J. J. Augustin, 1939. 161 pp.

———. *Navajo Medicine Man*. New York: J. J. Augustin, 1939. 83 pp.

———. *Navajo Religion: A Study of Symbolism*. New York: Pantheon, 1950. 2 vols.

———. *Navajo Shepherd and Weaver*. New York: J. J. Augustin, 1936. 222 pp.

———. *Spider Woman*. New York: Macmillan, 1934. 287 pp.

RODEE, MARIAN F. *Old Navajo Rugs*. Santa Fe: University of New Mexico Press, 1981. 113 pp.

———. *Southwestern Weaving*. Albuquerque: University of New Mexico Press, 1977. 176 pp.

ROESSEL, RUTH. "Navajo Arts and Crafts." In Smithsonian Institution, Bureau of American Ethnology, *Handbook of North American Indians*, vol. 10. Washington, D.C., 1983, pp. 592–604.

SAPIR, EDWARD. "A Navajo Sand Painting Blanket." *American Anthropologist*, vol. 37 (1935), pp. 609–16.

Shared Horizons: Navajo Textiles. Santa Fe: Wheelwright Museum, 1980, n.p.

SIMMONS, KATINA. "Oriental Influences in Navajo Rug Design." In Emery and Fiske, eds., *Ethnographic Textiles of the Western Hemisphere*, 1977, pp. 445–52.

Spanish Textile Traditions of New Mexico and Colorado. Santa Fe: Museum of International Folk Art, 1979. 264 pp.

STEVENSON, JAMES. "Ceremonial of Hasjelti Dailjis and Mythical Sand Painting of the Navajo Indians." In Smithsonian Institution, Bureau of American Ethnology, *Eighth Annual Report*. Washington, D.C., 1891, pp. 229–85.

STOLLER, IRENE P. "The Revival Period of Navajo Weaving." In Emery and Fiske, eds., *Ethnographic Textiles of the Western Hemisphere*, 1977, pp. 453–566.

TANNER, CLARA LEE. "Sandpaintings of the Indians of the Southwest." *The Kiva* (Arizona State Museum, Tucson), vol. 13 (1948), pp. 26–36.

———. *Southwestern Indian Craft Arts*. Tucson: University of Arizona Press, 1968. 206 pp.

TOZZER, ALFRED M. "A Navajo Sand Picture of the Rain Gods and Its Attending Ceremony." In International Congress of Americanists, *Proceedings of the International Congress of Americanists*, vol. 13. New York, 1902, pp. 147–56.

UTLEY, ROBERT M. "The Reservation Trader in Navajo History." *El Palacio* (Museum of New Mexico, Santa Fe), vol. 48 (1961), pp. 5–27.

"The Weavers of Chimayó." Santa Fe: *New Mexico Sun Trails*, vol. 2 (1954), pp. 10–11.

WHEAT, JOE BEN. "Documentary Basis for Material Changes and Design Styles in Navajo Blanket Weaving." In Emery and Fiske, eds., *Ethnographic Textiles of the Western Hemisphere*, 1977, pp. 420–40.

———. *The Gift of Spiderwoman*. Philadelphia: University of Pennsylvania, University Museum, 1984. 48 pp.

———. *Navajo Blankets: From the Collection of Anthony Berlant*. Tucson: University of Arizona, Museum of Art, 1974, n.p.

———. "The Navajo Chief Blanket." *American Indian Art*, vol. 1 (1976), pp. 44–53.

———. *Patterns and Sources of Navajo Weaving*. Denver: Harmsen, 1975. 68 pp.

———. "Rio Grande, Pueblo and Navajo Weavers: Cross Cultural Influences." In *Spanish Textile Tradition of New Mexico and Colorado*. Santa Fe: Museum of International Folk Art, 1979, pp. 29–36.

———. "Spanish-American and Navajo Weaving, 1600 to Now." In *Papers of the New Mexico Archaeological Society*, vol. 3. Santa Fe, 1976, pp. 199–226.

———. "Three Centuries of Navajo Weaving." *Arizona Highways*, vol. 50 (1974), pp. 22ff.

WHEELWRIGHT, MARY C. *Emergence Myth According to the Hanelthnayhe or Upward-reaching Rite*. Santa Fe: Museum of Navajo Ceremonial Art, 1949. 186 pp.

———. *Hail Chant and Water Chant*. Santa Fe: Museum of Navajo Ceremonial Art, 1946. 237 pp.

———. *The Myth and Prayers of the Great Star Chant . . . and the Coyote Chant*. Santa Fe: Museum of Navajo Ceremonial Art, 1956. 190 pp.

WYMAN, LELAND C. *The Sandpaintings of the Kayenta Navajo*. Albuquerque: University of New Mexico Press, 1952. 120 pp.

YEALTH, SARAH. "The Making of Navajo Blankets." *El Palacio* (Museum of New Mexico, Santa Fe), vol. 40 (1936), pp. 7ff.

INDEX